IMAGES
of America

ORANGE

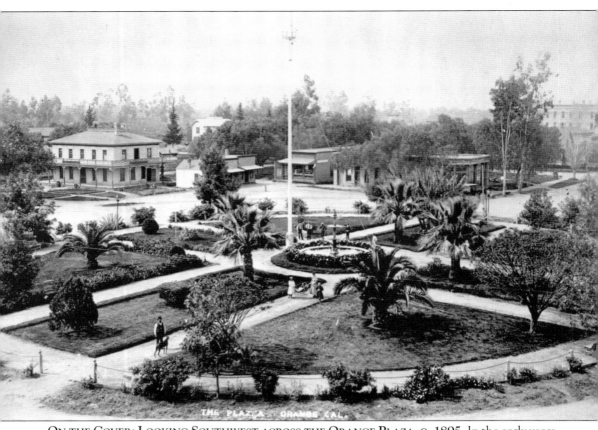

ON THE COVER: LOOKING SOUTHWEST ACROSS THE ORANGE PLAZA, C. 1895. In the early years, the Plaza was the commercial, social, and even the geographical center of the city of Orange. Today it remains the heart of the community and its symbolic center. (First American Corporation.)

IMAGES
of America

ORANGE

Phil Brigandi

ARCADIA
PUBLISHING

Published by Arcadia Publishing
Charleston SC, Chicago IL, Portsmouth NH, San Francisco CA

Printed in the United States of America

Library of Congress Catalog Card Number: 2008924121

For all general information contact Arcadia Publishing at:
Telephone 843-853-2070
Fax 843-853-0044
E-mail sales@arcadiapublishing.com
For customer service and orders:
Toll-Free 1-888-313-2665

Visit us on the Internet at www.arcadiapublishing.com

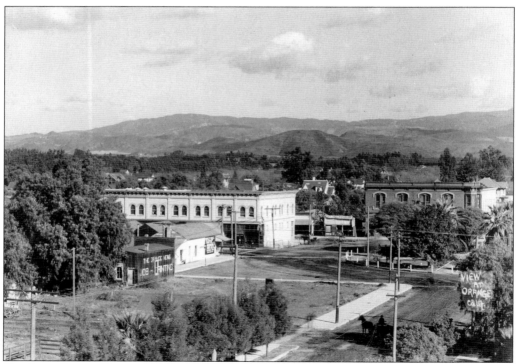

THE LAST EMPTY CORNER ON THE PLAZA, C. 1907. Orange was growing in the early 1900s, with old pioneer-store buildings being replaced by modern brick business blocks, and the downtown area filling in. This last empty corner along West Chapman Avenue was finally filled in 1908 with the construction of the Jorn Building. (Author's collection.)

CONTENTS

ACKNOWLEDGMENTS

After nearly 35 years of trying to document Orange's past, my list of benefactors has grown very long. From the time I first set out on my journey, I have always found our local old-timers to be courteous, helpful, and supportive. I thank them all.

To save space, I have abbreviated the credit lines in my photograph captions. Thanks are due to: the Local History Collection at the Orange Public Library and History Center (which now holds the collections of the Orange Community Historical Society); the Don Meadows Collection at the Department of Special Collections, University of California, Irvine, Libraries; the University Archives and Special Collections, California State University, Fullerton; the Orange County Archives; the Old Orange County Courthouse Museum; the Sherman Library; Orange High School; the Orange Friendly Center; the First United Methodist Church of Orange; the Orange Grove Lodge No. 293 F&AM; Ron Sands's Historical Panoramics of Orange County, and, as always, the historical library of the First American Corporation.

A number of individuals have also provided images for this book. Standing at the head of the list is Tom Pulley, one of Orange County's major postcard collectors, who has contributed to several Arcadia books. When he heard I was doing a book on Orange, I did not even have a chance to ask him for his help; he just showed up with a thick binder of postcards and left them for me to copy. Others who provided photographs from their own collections were Ethel Burnette, Walter E. "Gene" Crane, Duncan Clark, Ken Claypool, Al Eisenbraun, Helen Guillou, Mark Hall-Patton, Pat Hearle, Carol Jordan, Marguerite Parks, Gladys Reeves, Marjorie Sherrill, Jim Sleeper, Dr. G. Abbott Smith, and Kellar Watson Jr. All of the other images come from my own files, which include a collection of original photographs taken by a pioneer Orange photographer, Adolph Dittmer, given to me by his son, the late Harold Dittmer.

INTRODUCTION

Orange is a modern city with a small-town feel. Even today, many people still see Orange as a small town, a unique place in the sea of suburbia that has washed over Orange County. That's because Orange is not just another city, but a community with neighborhoods, businesses, organizations, and people—people who feel connected to where they live. That's what gives Orange its small-town feel.

Another thing that makes Orange distinctive is its history—or rather, its sense of history. Every place has a history; but in Orange, our history is still all around us, a constant reminder that we are part of an ongoing story that began almost 140 years ago.

To cut things down to size, this book will only trace the story of Orange up to 1950, just before the modern era of freeways and tract housing begins. One of the challenges of a book like this is trying to write for the old-timers, the newcomers, and all the rest of us in between. That means including images that will make longtime residents smile and details that will help newcomers to better understand their community.

Like many Southern California communities, Orange began as a real estate venture. Two Los Angeles attorneys, Alfred Beck Chapman and Andrew Glassell, began buying up land in the Santa Ana Valley in the 1860s. Chapman eventually owned more than 3,000 acres between the Santa Ana River and the Santiago Creek. In 1870, he had the land subdivided into farm lots and placed it on the market.

But Chapman had bigger plans. In 1871, he hired Andrew Glassell's brother, Capt. William T. Glassell, to lay out a town site near the center of the tract, with 10-acre farm lots all around. Captain Glassell also became the tract agent, and in the summer of 1871, the town of Richland was born.

Richland had a short life. In 1873, local residents sent an application to Washington to request a post office, but it turned out there was already another Richland, California, so Richland became Orange.

Local legend says that the winner of a poker game selected the name, but as is often the case, local legend gets it wrong. Others point out that the Glassell family once lived in Orange County, Virginia. However, there was another, more immediate motivation. Even in 1873, there were already plans to form Orange County, and what better name for an up-and-coming community in Orange County than Orange?

At the time, there was not a single orange grove in what would become Orange County. Although grapes and grain were the big crops in those days, Southern California was promoting itself as a semitropical paradise or America's Mediterranean coast. Oranges fit that image. It was only later that they became the dominant crop in the city that bears their name.

In the 1880s, a rate war between the Santa Fe and Southern Pacific Railroads launched a frantic real estate boom in Southern California. New towns and new subdivisions spread across the land, and established communities like Orange enjoyed a surge in population, economic importance, and civic amenities.

Flush with growth, in 1888 the residents of Orange voted to incorporate. A year later, Orange County finally formed out of the southern end of Los Angeles County. Orange then fought for the county seat, but was easily outdistanced by Santa Ana.

The boom years also brought Orange's best-loved landmark. The original plans for Orange included an open square in the middle of town, set aside as a public plaza. After years of neglect, in 1886 a circular park was established in the center of the square. Trees, grass, and flowers were planted, and in 1887, a decorative fountain was added. Today the Plaza remains the symbolic heart of the city of Orange; a place true locals never call "the circle."

But like all booms, the railroad boom of the 1880s eventually went bust. Times were tight through the 1890s until the citrus industry got on its feet. And make no mistake about it; citrus was a serious industry. It incorporated a huge interlocking series of individual growers, packinghouse associations, marketing organizations, cultivators, irrigators, fumigators, pickers, graders, packers, box makers, label printers, shippers, auctioneers, and more.

By 1910, oranges were the dominant crop in the area. Spring-ripening Valencia oranges proved to be the most successful variety, but other growers planted lemons, limes, and wintertime navel oranges. Over the years, more than a dozen packinghouses operated in and around Orange. The Santiago Orange Growers Association grew to become the largest Valencia packinghouse in the nation, sending out more than 800,000 boxes of fruit in 1929, its banner season. By the 1930s, Orange County was producing one-sixth of the nation's Valencia crop.

After 1900, the city of Orange began to grow again. Most of the historic houses that can still be found in downtown Orange were built between 1905 and 1930. The business district around the Plaza grew up as well, with modern, two-story brick buildings replacing wooden, pioneer storefronts.

The citrus industry even carried Orange through the first few years of the Great Depression, but eventually the nation's economic woes sent fruit prices tumbling. In the early 1930s, before federal aid arrived, Orange looked after its own through a local welfare organization. Ironically, the coming of World War II finally revived the nation's economy.

The late 1940s saw the beginnings of Southern California's postwar boom. In Orange, new homes began springing up to fill in the older neighborhoods, but it was not until 1950 that the first large housing tract went on the market.

The 1950 census counted just over 10,000 people in Orange—only 2,000 more than in 1930. Twenty years later, the population had grown to 77,000. In 1985, Orange passed the 100,000 mark. Today our population is over 135,000, but a small-town feel remains.

One

PIONEER DAYS

Orange's earliest years were a time of trial and error, of growth and setbacks. Many new communities were founded in Orange County in the last third of the 19th century, but not all of them survived. It took the right combination of land, water, and opportunity, and the determination of the pioneers.

The pioneers dug irrigation ditches, cleared the land, and planted the first crops. Pioneers established the first stores, schools, and churches. It was pioneers who tried new crops, launched new industries, and built a community.

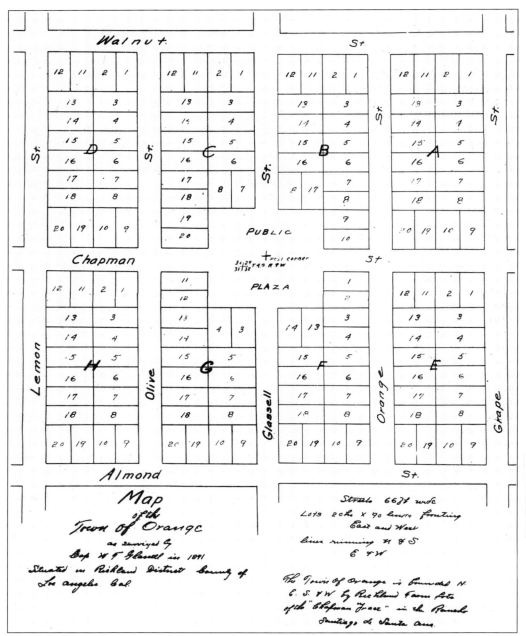

ORANGE TRACT MAP, 1871. The original town site of Orange was laid out by Capt. William T. Glassell, who started his survey in the center of the Plaza. Just eight square blocks, the town site ran from Almond Avenue to Walnut Avenue (now Maple) and from Lemon Street to Grape Street (now Grand). Surrounding the tract were 10-acre farm lots. (Orange County Archives.)

ALFRED BECK CHAPMAN (1829–1915). A successful Los Angeles attorney and pioneer citrus rancher, A. B. Chapman was the driving force behind the founding of Orange. For him, the town was simply a real estate investment, and he never lived here. (First American Corporation.)

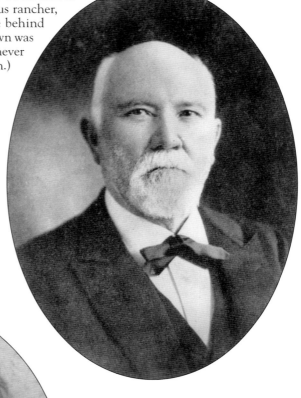

ANDREW GLASSELL (1827–1901). Chapman's longtime friend and legal partner, Andrew Glassell was the other principal investor in the founding of Orange. He made his home in Glendale, where Glassell Park is named for him. (Orange Public Library.)

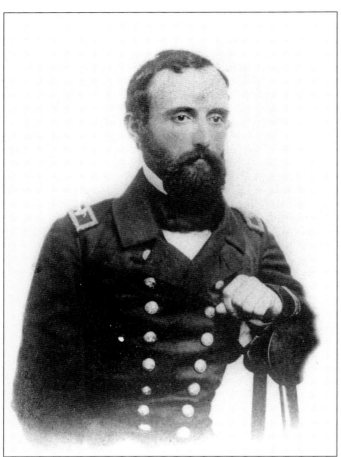

CAPT. WILLIAM T. GLASSELL (1831–1879). Andrew Glassell's brother, W. T. Glassell, was the original tract agent and first resident of the new town of Orange. He surveyed the town site, supervised the construction of an irrigation ditch, and promoted the community. A Confederate Army, Civil War veteran, he developed one of the first submarine-style attack boats, the *David*, and was imprisoned twice in Union Army prisoner of war camps. (Orange Public Library.)

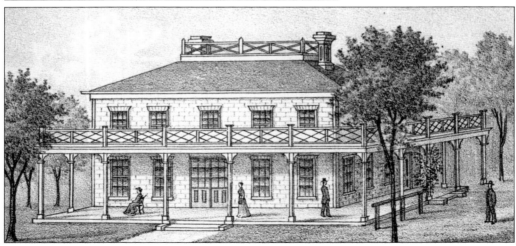

PLAZA HOTEL, 1880. One of the first substantial buildings in Orange was the Plaza Hotel, which was built in 1874–1875 as a sanitarium. Later it served as a hotel, the Orange Public Library, and city hall. Located on the west side of South Glassell Street, just south of the Plaza, the hotel stood until 1905. (Author's collection.)

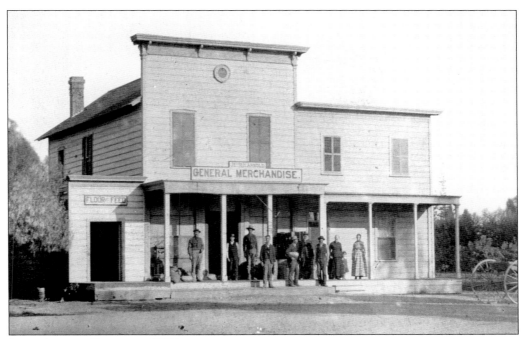

JESSE ARNOLD STORE, C. 1885. Built in 1874, the Beach Building was the first two-story building downtown, with a store below and a public hall above. Located at 101 South Glassell Street, the building was replaced by the present structure in 1901. This is the earliest known photograph of downtown Orange, taken sometime between 1881, when Jesse Arnold opened his store here, and 1886, when he built an addition on the rear of the old building. (Orange Public Library.)

DR. GEORGE H. BEACH (1840–1917). Orange's first physician, first postmaster, and builder of the Beach Building, Dr. Beach came to town with his family in 1873. (Orange County Archives.)

ORANGE WATER COMPANY, C. 1895. Wells provided most of the domestic water in early Orange. The Orange Water Company formed in 1876 to supply water for downtown. Originally located northwest of the Plaza, a new well (shown here) was later drilled near the northeast corner of Chapman Avenue and Shaffer Street. (University of California, Irvine, Don Meadows Collection.)

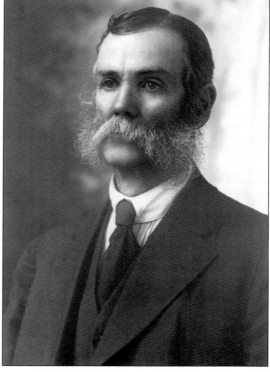

ED HONEY (1854–1938). One of Orange's best-known pioneers, Ed Honey came to town in 1876. After running a stage line between the railroad and downtown, he purchased the Orange Water Company in 1884. The private company was finally taken over by the city in 1905. (Orange Grove Lodge No. 293 F&AM.)

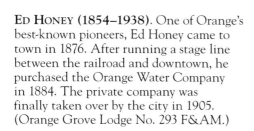

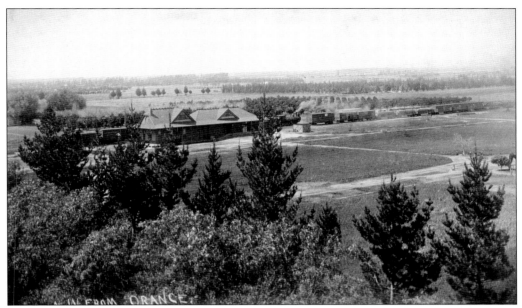

LOOKING NORTHWEST ACROSS ORANGE, C. 1890. In this view, open land stretches into the distance past the new Santa Fe depot. A few orange groves and windbreaks are visible, but much of the area is still undeveloped. (University of California, Irvine, Don Meadows Collection.)

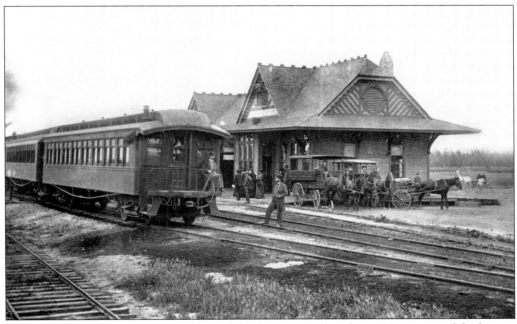

SANTA FE DEPOT, C. 1891. The arrival of the Santa Fe Railroad in 1887 was one of the biggest events of the decade. As the rails spread throughout Southern California, they brought commerce, tourism, and—for the first year or two—an economic boom. Orange's original wooden depot stood until 1938, when the present depot opened. (First American Corporation.)

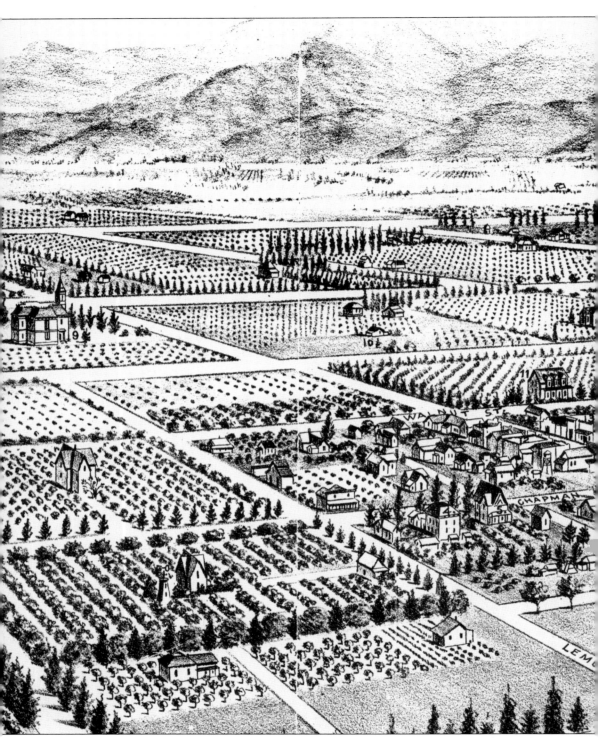

BIRD'S-EYE VIEW OF ORANGE, 1886. Drawn by an artist for an early promotional pamphlet, this bird's-eye view of the community is surprisingly accurate. Only a handful of the buildings

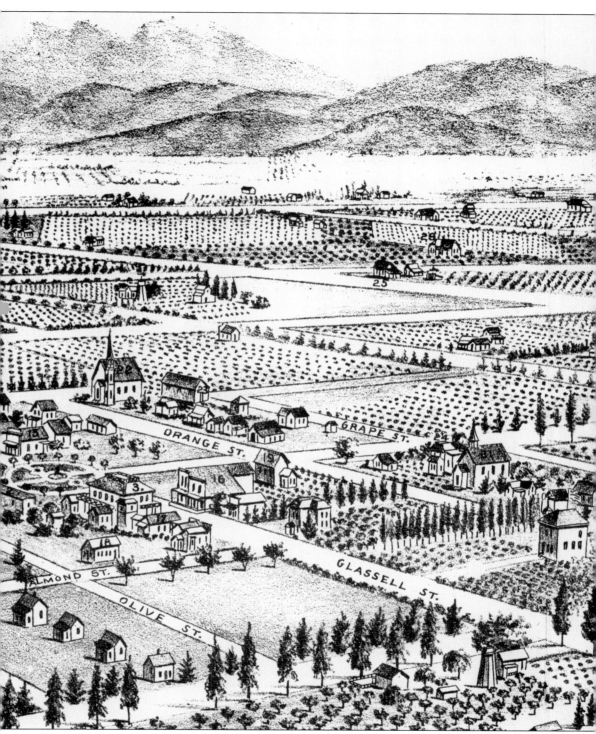

shown survive, including the Shaffer house and the Vineland Home. (University of California, Irvine, Don Meadows Collection.)

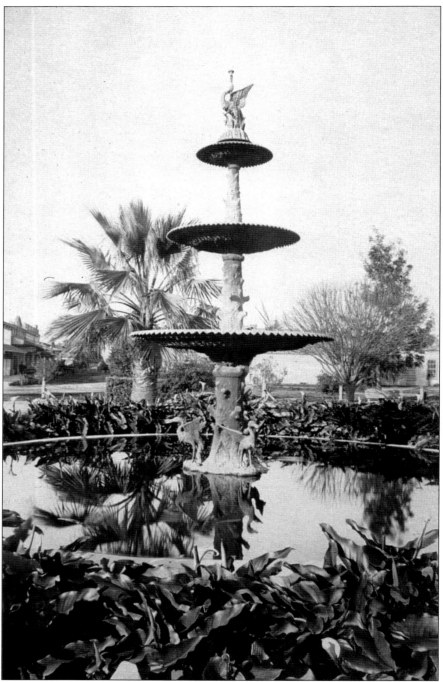

PLAZA FOUNTAIN, C. 1888. The new Plaza Fountain was the pride of Orange. The Plaza Square had been a dusty, weedy, no-man's land until a park was built in the center in 1886. The women of Orange then set out to raise the funds for a decorative fountain, installed in 1887. The fountain stood in the center of town until 1937. Fully restored, it now stands at the new Orange Public Library. (University of California, Irvine, Don Meadows Collection.)

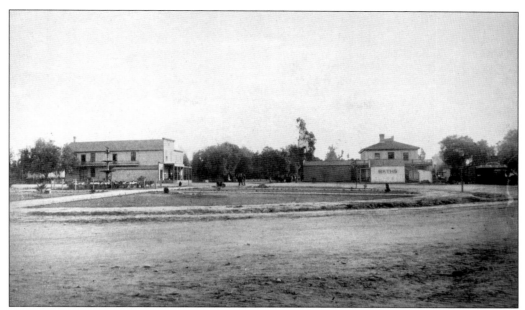

EARLIEST KNOWN PHOTOGRAPH OF THE PLAZA, 1887. The photographer was facing south across the new Plaza. The picture was taken shortly after the fountain was installed. There had been quite an argument between putting a park in the center of the Plaza or building four smaller parks in the corners. On the left is the Beach Building; on the right, the long, low Tener Building, the two-story Plaza Hotel, and a small real estate office. (Orange Public Library.)

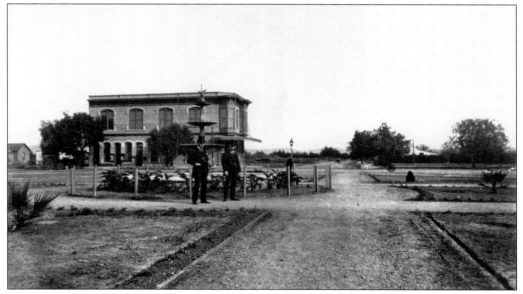

THE NEW PLAZA, LOOKING EAST, 1887. This is perhaps the most famous early photograph of Orange, showing the new Plaza Fountain and the two-story Bank of Orange building. The identity of the two dignified gentlemen remains something of a mystery. Often the two men are identified as the town founders, Alfred Chapman and Andrew Glassell, but there is still some question about their identities. Orange historian Don Meadows once suggested that it was actually Chapman and David Hewes, a prominent local rancher. (Orange Public Library.)

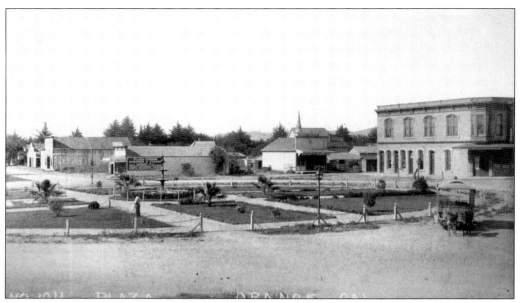

LOOKING NORTHEAST ACROSS THE PLAZA, C. 1890. Here, the Plaza is beginning to take shape as downtown Orange grows up around it. Notice the horse-drawn (or rather, burro-drawn) streetcar that ran between Santa Ana, Orange, and Tustin, and the steeple of the Presbyterian Church in the distance. (Orange Pubic Library.)

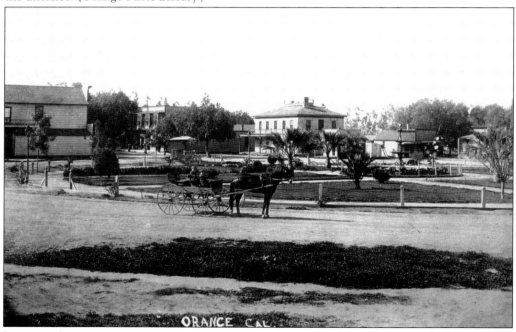

LOOKING SOUTHWEST ACROSS THE PLAZA, C. 1890. The Beach Building is on the left, the two-story Plaza Hotel is in the center, and between them is the two-story Tener Block, which housed Orange's post office and library. Moved to North Olive Street in 1908 to make way for the Ehlen and Grote Block, the old building became the Olive Hotel and stood until 1973. (University of California, Irvine, Don Meadows Collection.)

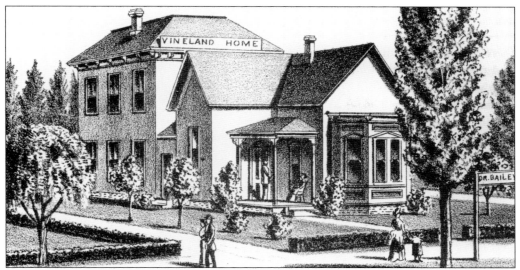

VINELAND HOME, 1886. Built in 1886 by Dr. W. F. Bailey as an addition to his home and office, the Vineland opened just at the start of the frantic real estate boom that swept Southern California in the 1880s, as tourists poured into the area. Dr. Bailey's home is long gone, but the hotel still stands in the rear at 228 West Chapman Avenue. (University of California, Irvine, Don Meadows Collection.)

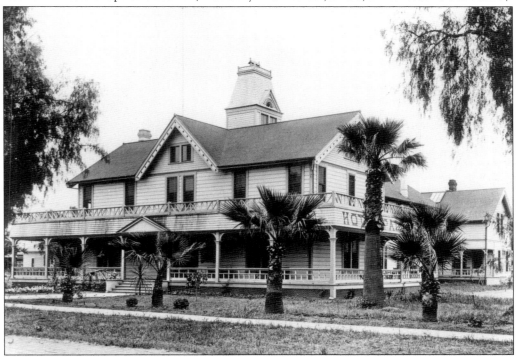

PALMYRA HOTEL, 1907. Orange's showplace during the boom of the 1880s, the Palmyra was built in 1887 by real estate developer C. Z. Culver, who found many of his investors in his old hometown of Palmyra, New York. It was located at the southeast corner of Glassell Street and Palmyra Avenue. When the boom went bust, Culver went broke and skipped to Mexico. His hotel went into a long decline and the last of it was finally torn down in 1970. (Orange Public Library.)

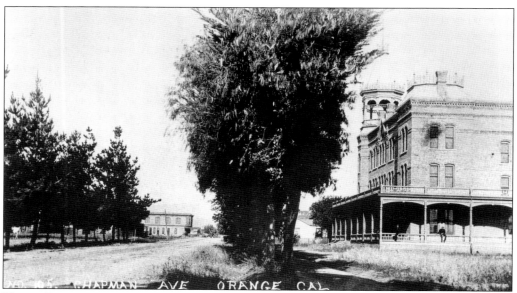

HOTEL ROCHESTER ON WEST CHAPMAN AVENUE, C. 1890. Designed to eclipse the Palmyra, the three-story Hotel Rochester was still under construction when the boom went bust in 1888. It was never completed. It was offered up as a ready-made courthouse if Orange was selected as the county seat for the new Orange County in 1889, but that honor went to Santa Ana instead. The brick behemoth was finally razed in 1931, and the downtown post office was built on the site. (First American Corporation.)

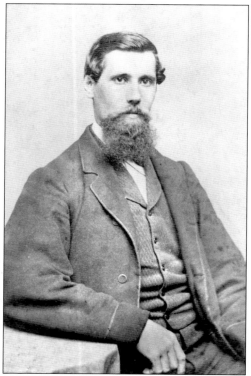

ORANGE'S FIRST MAYOR, WILLIAM BLASDALE. William Blasdale (1834–1892) came to town in 1875 and was a pioneer citrus grower. When the city of Orange voted to incorporate in 1888, he was selected as the first mayor. (Helen Blasdale Guillou.)

P. J. SHAFFER (1823–1907). Peter James Shaffer was one of the first settlers in Orange, buying land here in 1871. He went on to serve on the first Orange City Council in 1888. He lived here almost continuously until his death in 1907. (Orange County Archives.)

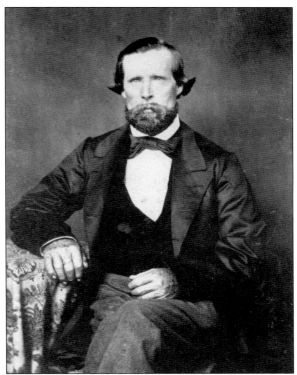

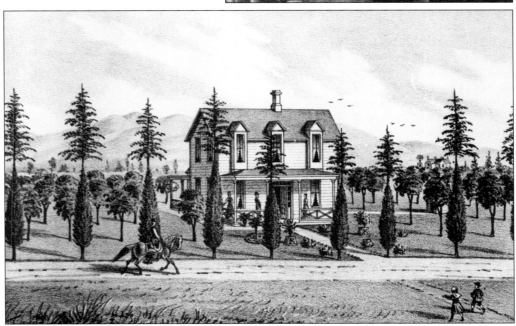

SHAFFER HOUSE, 1880. Built by P. J. Shaffer in 1874, this is now the oldest surviving house in Orange. It originally stood at the northwest corner of Maple and Orange, but around 1905 moved to 221 North Orange Street. Beginning in the 1890s, several additions were built onto the house, but some of the original details survive. (Author's collection.)

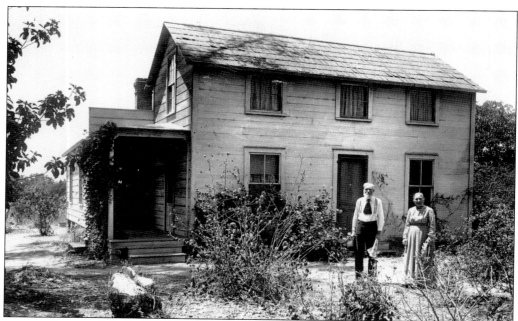

JUDSON SANDERS'S RANCH HOUSE, C. 1910. Judson and Elizabeth Sanders came to Orange in 1873 and lived 36 years on a ranch near Chapman and Prospect. Their old ranch house is a good example of a pioneer home, simple and unadorned. Judson Sanders died in 1914, and Elizabeth Sanders died in 1927 at the age of 93. (Author's collection.)

DR. SEEBER'S HOUSE, C. 1888. By the 1880s, more substantial homes were being built in Orange. Dr. Frank D. Seeber's house, which once stood at the southeast corner of Chapman Avenue and Jameson Street, is a fine example. It was completed shortly before his death in 1889 when he was just 39 years of age. (California State University, Fullerton, Special Collections.)

Two

AROUND DOWNTOWN

Orange grew around the Plaza. From the earliest days, it was the commercial, social, civic, and even the geographical center of town. Everything in town was located just a few blocks from the Plaza.

By 1910, downtown Orange offered local residents almost everything they needed, with grocery stores, hardware stores, drug stores, furniture stores, shoe stores, blacksmith shops, banks, two local newspapers, but no saloons; Orange had voted the town dry shortly after incorporation in 1888.

On Saturday nights, downtown was alive with people, both shopping and visiting. For years, the downtown stores traded goods for eggs and produce. Almost all of them ran accounts for the local citrus growers, waiting, as the growers did, for the summer months when the checks from the packinghouses arrived.

Unlike some other cities in Orange County, much of old downtown Orange has survived, including both business blocks and the blocks of early homes. Most of them are now listed on the National Register of Historic Places.

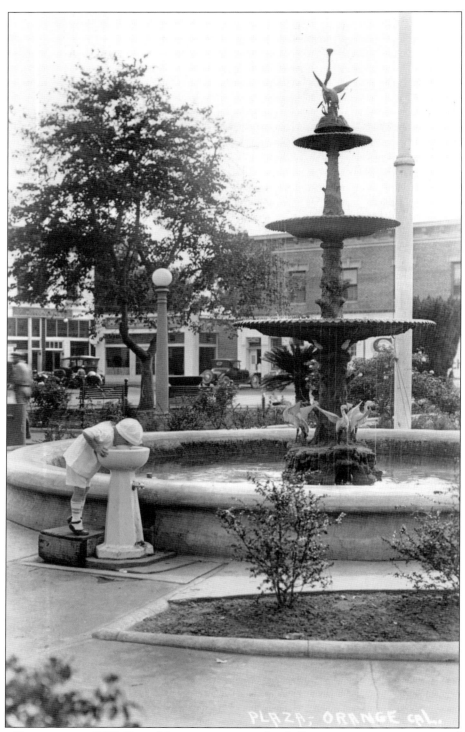

PLAZA, ORANGE CAL.

PLAZA FOUNTAIN, C. 1925. One of the iconic pictures of early Orange, it continues to inspire debate among the old-timers as to the identity of the little child getting a drink. (Author's collection.)

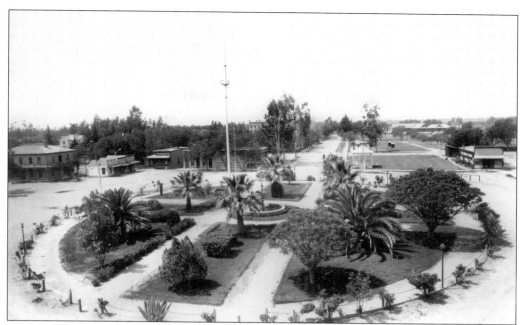

LOOKING WEST ACROSS DOWNTOWN, C. 1900. Downtown Orange still had an open feel as the 20th century began. Notice the bandstand on the corner and the original Plaza flagpole made from a ship's mast. (Orange Public Library.)

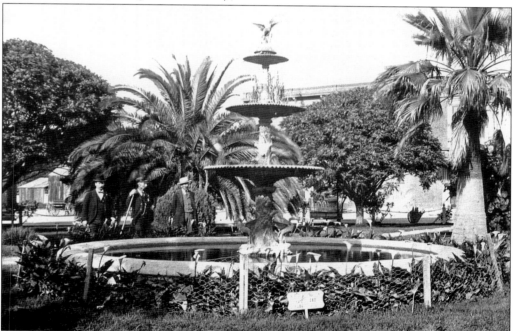

PLAZA FOUNTAIN, C. 1904. The second man from the left is R. J. "Daddy" Fyffe, who served as city marshall from 1903–1906. Besides serving as the local police force, he was also the Plaza caretaker, street superintendent, and license collector. (University of California, Irvine, Don Meadows Collection.)

LOOKING SOUTH THROUGH THE PLAZA, C. 1925. The tree-filled Plaza lends a different feel to downtown Orange. It is an oasis in the middle of town. (Tom Pulley.)

LOOKING WEST THROUGH THE PLAZA, C. 1935. Some of the earliest plantings in the park still survive. The oldest are the palm trees that surround the fountain. (Tom Pulley.)

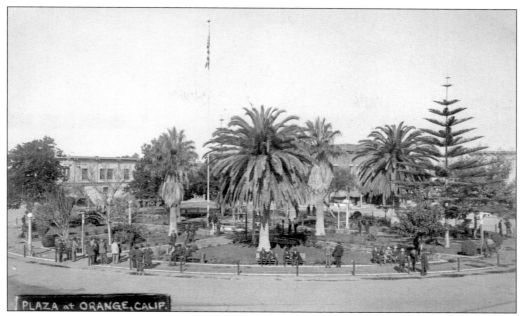

PLAZA STATESMEN, C. 1915. The Plaza was a natural gathering spot in the center of town. The men who would gather day by day to talk about the affairs of the world were jokingly known as the "Plaza Statesmen." (Author's collection.)

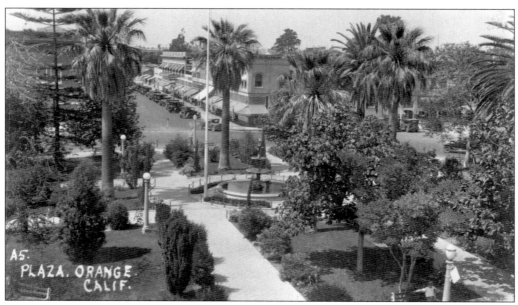

LOOKING NORTH ACROSS THE PLAZA, C. 1930. Except for the new fountain, and the loss of the awnings on the buildings, the view down North Glassell Street is little changed today. (Author's collection.)

PLAZA FOUNTAIN, 1947. The original Plaza Fountain was replaced in 1937 by what some old-timers always called "that ugly electric fountain." The new fountain came from Westinghouse and featured 126 different lighting and flow combinations. The old fountain became the wading pool at the municipal plunge at Hart Park. Recently restored, it now stands outside the new Orange Public Library. (Old Courthouse Museum, Geivet Collection.)

EAST CHAPMAN AVENUE, C. 1920. The Plaza Square gives the center of town eight corners, instead of the usual four. These corners naturally became some of the prime commercial real estate downtown. (First American Corporation.)

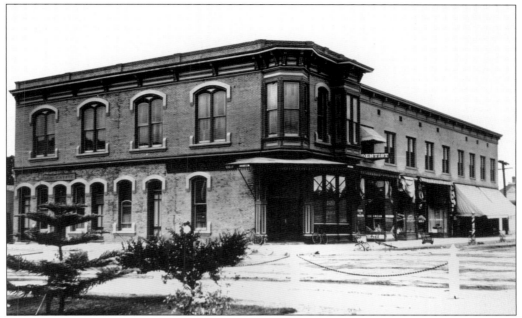

BANK OF ORANGE AND WHITTED BLOCK, 1907. Four of the downtown corners had banks on them at one time or another. The north side of East Chapman Avenue at the Plaza Square has been home to a bank since the Bank of Orange opened their offices there in 1887. The Whitted Block beyond was built in 1902. (Orange Public Library.)

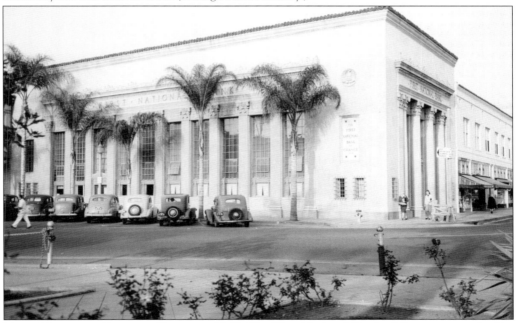

FIRST NATIONAL BANK OF ORANGE, 1947. The First National Bank of Orange, organized in 1905, eventually absorbed the old Bank of Orange, and in 1928 erected this fine new building. First National was finally bought out by Wells Fargo in 1977, who still occupy the corner. (Old Courthouse Museum, Geivet Collection.)

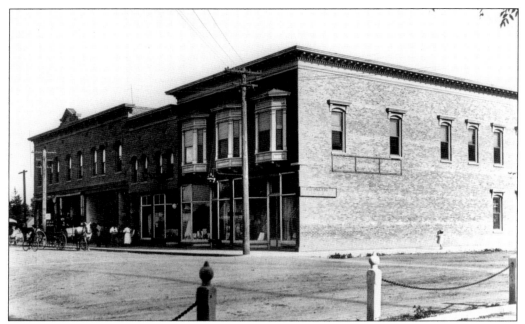

EAST CHAPMAN AVENUE, 1907. After some tough economic times in the 1890s, downtown Orange began to grow again. The Carpenter Building on the right was built in 1899. The Odd Fellows Hall on the left was completed in 1901. The building was designed with storefronts for rent on the ground floor and offices and meetings rooms on the second floor. (Orange Public Library.)

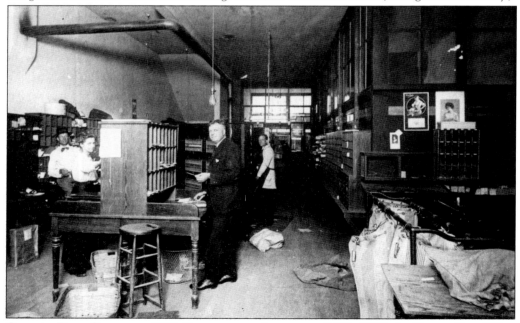

ORANGE POST OFFICE, C. 1910. For a quarter of a century (1901–1926) the Orange Post Office was located in the Odd Fellows Building at 116 East Chapman Avenue. Nelson Edwards, posing front and center, served as postmaster from 1906 to 1915. Later he became a county supervisor and eventually Orange County's state senator. (Walter E. Crane.)

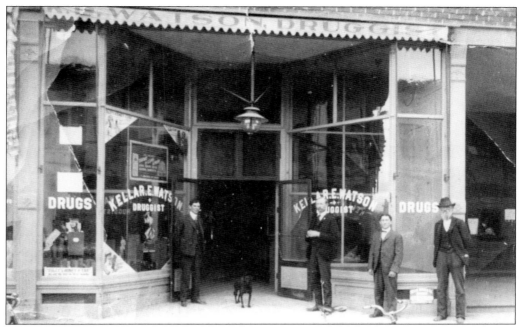

WATSON'S DRUG STORE, 1905. Founded in 1899 by Kellar Watson Sr., Watson's Drug Store is Orange's oldest and best-known business. Since 1901, it has operated out of the same building on East Chapman Avenue, although moving around between several different storefronts. This location is now the eastern half of the present drugstore. (Kellar Watson Jr.)

WATSON'S DRUG STORE, 1926. In 1926, Watson's Drug Store moved down to the corner and was given a complete makeover. The store remained there until 1949, when it moved to its current location. Kellar Watson Jr. took over the business from his father in the 1930s and ran the store until 1965. (Kellar Watson Jr.)

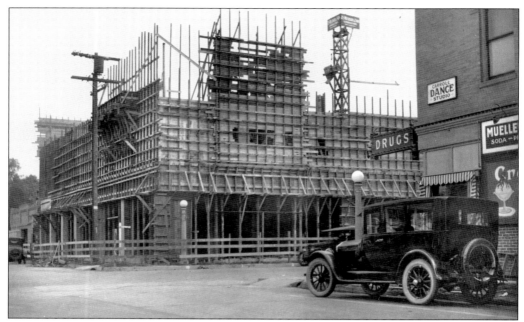

ODD FELLOWS HALL UNDER CONSTRUCTION, 1925. During the boom days of the 1920s, the local Odd Fellows lodge decided to build an impressive new three-story building. But with the coming of the Depression, they fell behind in their mortgage payments and lost the building to the bank. The Odd Fellows moved back to their old meeting rooms above Watson's Drug Store and the Elks Lodge took over the building, eventually buying it. They are still there today. (Sherman Library, Meadows Collection.)

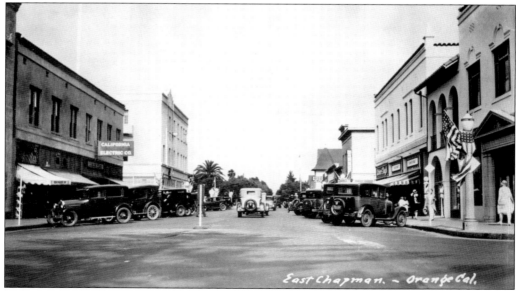

EAST CHAPMAN AVENUE, C. 1930. In 1927, the first city planning commission proposed a complete Mediterranean remodel of all of downtown, with stucco, red tile, and arches. The first buildings to be remodeled were on the south side of East Chapman Avenue. When the Depression came, the plan never went any further. (First American Corporation.)

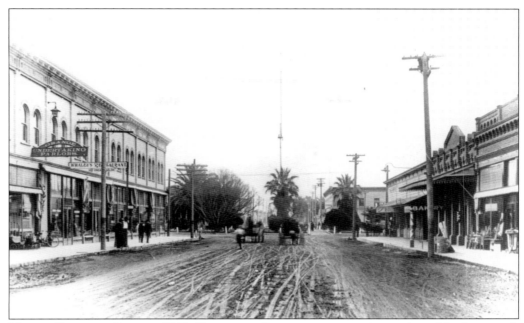

NORTH GLASSELL STREET, 1909. Downtown Orange was in transition when this photograph was taken. On the west side of the street, the old store buildings from the 1870s and 1880s still stand. On the east, the modern Edwards Block has been completed. And while the street is still dirt, it is lined by cement sidewalks. (Orange Public Library.)

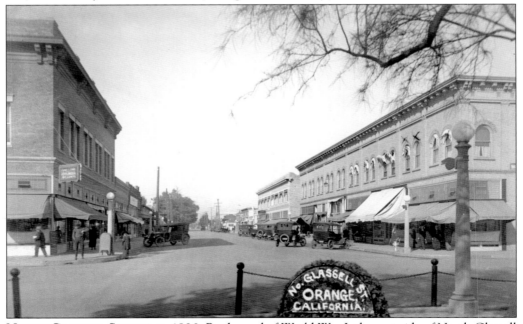

NORTH GLASSELL STREET, C. 1920. By the end of World War I, the east side of North Glassell was almost completely filled in with substantial brick buildings. On the west, the old, wooden store buildings were replaced by Campbell's Opera House, which has been the home of the Orange Masonic Lodge since 1923. (Tom Pulley.)

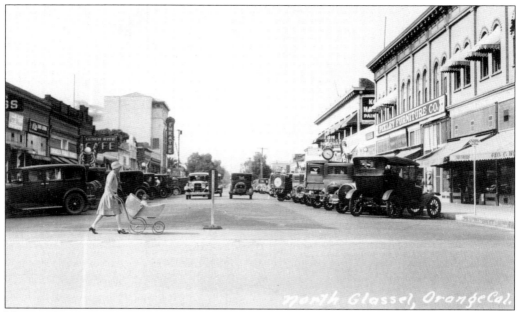

NORTH GLASSELL STREET, C. 1930. The business district continues to rise. The biggest new addition in this photograph is the Orange Theatre, which opened with the new "talking pictures" in 1929. The late Marguerite Parks, widow of mayor Rex Parks, used to say that she was the mother pushing the stroller across the street. (Tom Pulley.)

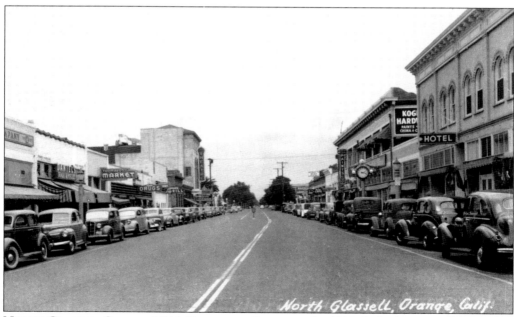

NORTH GLASSELL STREET, 1944. Downtown Orange in the 1940s looked very similar to today. Notice the signs out over the sidewalks for pedestrians, not just on the front of buildings for people driving by in cars. (Author's collection.)

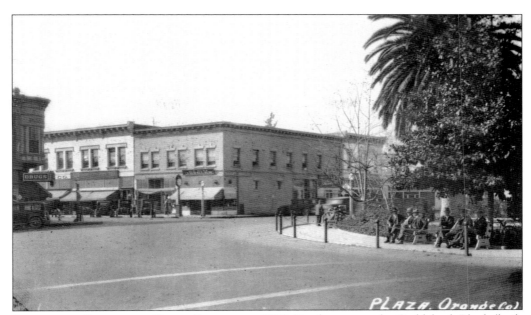

SOUTHWEST SIDE OF THE PLAZA SQUARE, C. 1930. On the corner, the Cuddeback Block (built in 1905) has taken the place of the old Plaza Hotel. On either side is the Ehlen and Grote Block, which wrapped around it. Built in 1908, Ehlen and Grote's "big white store" was the largest retailer in town for many years. (Tom Pulley.)

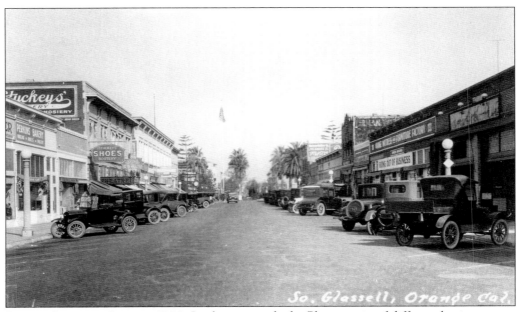

SOUTH GLASSELL STREET, 1928. Looking towards the Plaza, a mix of different businesses are visible, including Perkins Bakery, Stuckey's Shoes, the Colonial Theatre, Orange Hardware, and two drugstores: Harms and Dittmer's. (Tom Pulley.)

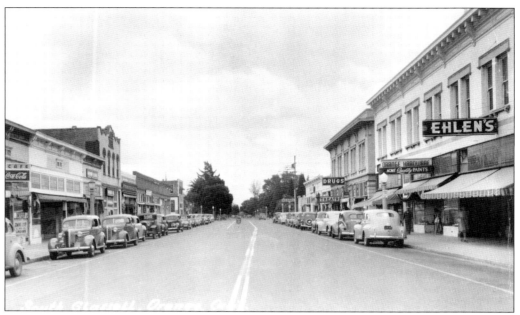

SOUTH GLASSELL STREET, 1944. Looking south a few years later, the east side of the street shows a variety of early storefronts. Most of them were later covered over or remodeled. Today it is sometimes difficult to know where one building ends and another begins. (Tom Pulley.)

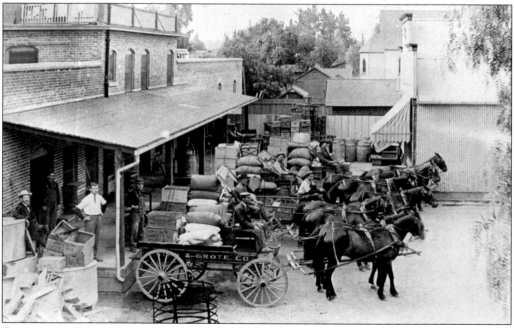

EHLEN AND GROTE DELIVERY WAGONS, 1909. Besides their store on South Glassell Street, Ehlen and Grote also provided delivery service to all the surrounding area. Ranchers could give the drivers their order on one trip and receive the items a few days later. The store carried groceries, hardware, clothing, shoes, and household goods. It finally closed in 1938, a victim of the Depression and the rise of the chain stores. (Orange Public Library.)

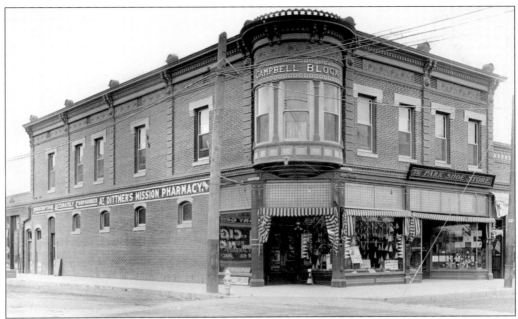

DITTMER'S MISSION PHARMACY, C. 1910. Founded by Adolph Dittmer in 1905, the Mission Pharmacy moved to 101 South Glassell Street in 1909. Dittmer was a photographer who took many of the familiar pictures of downtown Orange during this era, including this one. This building still stands, but the original brickwork was covered with an art moderne facade around 1938. (Author's collection.)

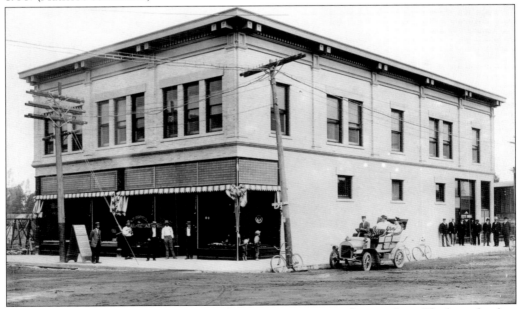

JORN BLOCK, 1908. The finishing touches are just going on the new Jorn Block as the first businesses move in along West Chapman Avenue. Around the corner on Plaza Square, the city rented several rooms for city hall. The building still stands, along with a matching addition on the west side, which was built in 1923. (Author's collection.)

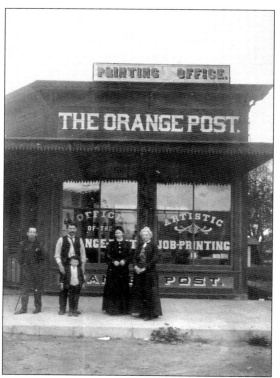

OFFICE OF THE ORANGE POST, 1904.
Posing outside are typesetter George
Howard, printer Charles Meadows,
his wife Adah, their son Donald, and
Alice Armor, who served as editor
and publisher from 1892 to 1915. The
building stood at 44 Plaza Square until
1920. The newspaper was published
until 1946. (University of California,
Irvine, Don Meadows Collection.)

ARMOR BUILDING, C. 1906. The Armor
Building was constructed as a store by
Orange's first county supervisor, Sam
Armor, in 1888. By this time, Hemphill
and Morse had a real estate office here
on the south corner of West Chapman
Avenue and Plaza Square. In 1907, a new
owner, Lewis Ainsworth, quadrupled
the size of the building, doubling the
size of the ground floor and adding
a second story. (Gladys Reeves.)

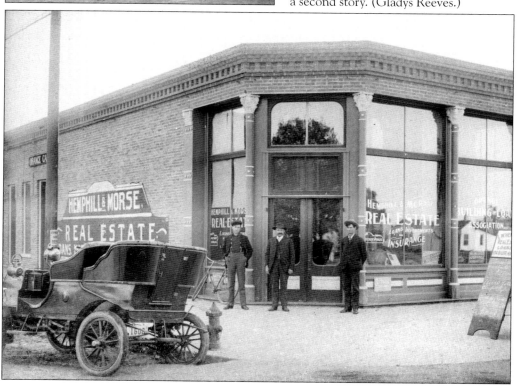

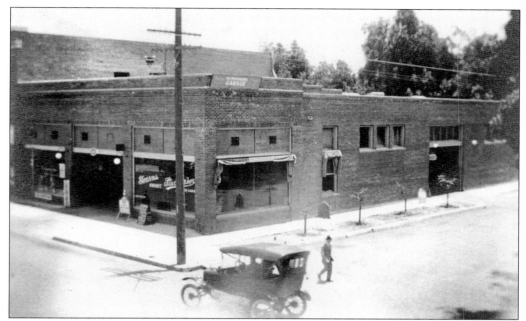

Sisson Building, c. 1922. As West Chapman Avenue filled in during the 1920s, many of the automobile-related businesses moved to that side of town. O. W. and Herbert Sisson built this garage building on the corner of Chapman and Olive around 1922. Later O. W. Sisson sold Goodyear tires here. In 1948, Harold Vollmer opened the Plaza Beverage Store in the old garage. (Author's collection.)

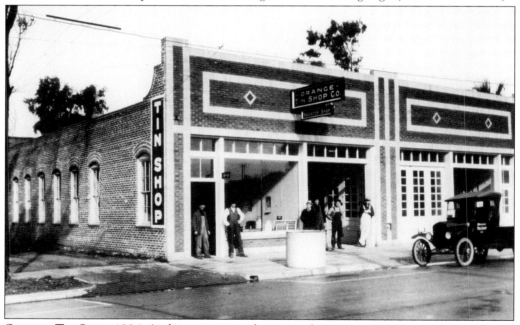

Orange Tin Shop, 1924. As downtown grew, businesses began moving east and west to Orange and Olive Streets. The new Orange Tin Shop was located at 132 North Orange Street. Co-owner Emanuel Eisenbraun is standing in the doorway on the left. This was one of a number of early businesses torn out in later years to provide parking for downtown. (Al Eisenbraun.)

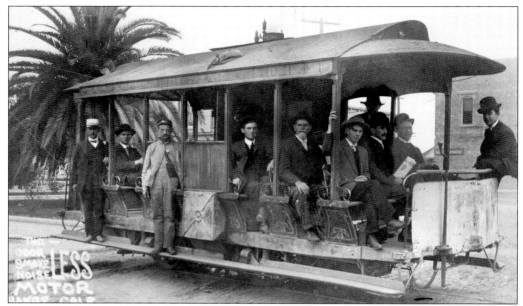

ORANGE DUMMY, C. 1906. A horse-drawn streetcar service was established between Orange and Santa Ana in 1888. The line ran south on Glassell Street to La Veta Avenue, then west to Main Street. Later this steam-powered car went into service. It was billed as odorless, smokeless, and noiseless, but was in fact none of those things. Locals dubbed it the Orange Dummy, or the Peanut Roaster, for its shrill steam whistle. (Tom Pulley.)

PACIFIC ELECTRIC DEPOT, 1964. The Pacific Electric company bought out the old Santa Ana–Orange streetcar line 1901. In 1914, the tracks were moved to Lemon Street and, in 1918, this new passenger depot was built just north of Chapman Avenue. Streetcar service to Orange continued until 1930, when it was replaced by buses. (First American Corporation.)

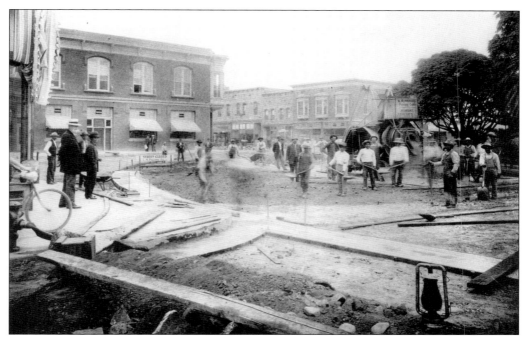

PAVING THE PLAZA SQUARE, 1912. Like so many things in Orange, paving the streets started around the Plaza then spread its way out through downtown. (University of California, Irvine, Don Meadows Collection.)

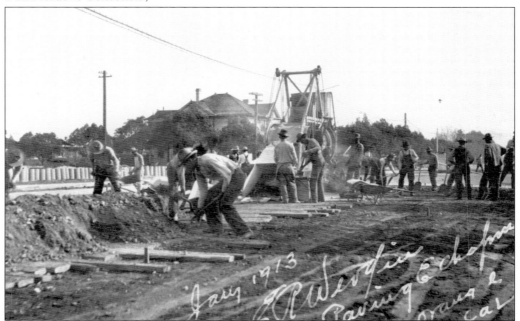

PAVING EAST CHAPMAN AVENUE, 1913. E. R. Werdin, the city's original paving contractor, got himself into several battles with local residents over the quality of his work. At least one lawsuit resulted and Werdin replied by trying to have the plaintiff declared insane; both cases failed. (Tom Pulley.)

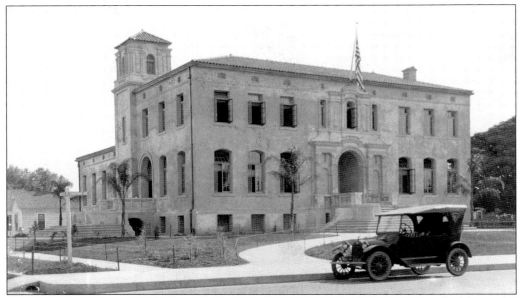

New City Hall, 1921. After years of renting space in various downtown store buildings, the city finally built its own city hall in 1921. Located on the site of today's city council chambers, it was torn down in 1962 to make way for the current Orange Civic Center. (Tom Pulley.)

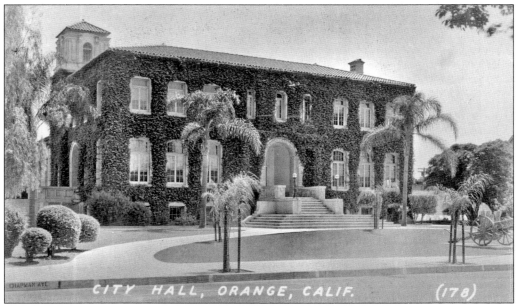

CITY HALL, ORANGE, CALIF. (178)

City Hall, c. 1935. City hall quickly accumulated a thick coating of ivy and a cannon on the lawn. The original World War I cannon was melted down for scrap during the World War II. Now a World War II cannon stands in front of the Orange Civic Center. (Author's collection.)

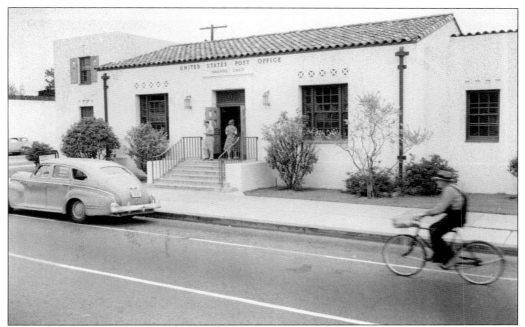

ORANGE POST OFFICE, 1947. In 1935, the Works Progress Administration (WPA) built a new downtown post office. It served as Orange's main office until the current headquarters on Tustin Avenue opened in 1971. Today the downtown office is known as the Plaza Station. (Old Courthouse Museum, Geivet Collection.)

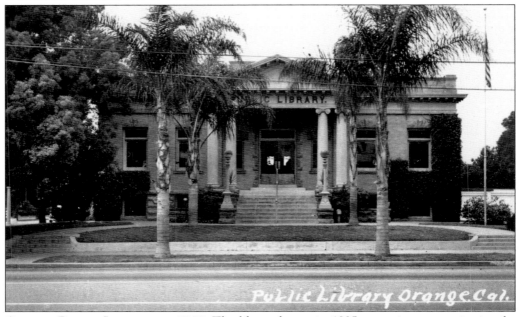

ORANGE PUBLIC LIBRARY, C. 1940. The library began in 1885 as a private organization for members only. It became a public library when the city took it over in 1894. In 1908, a $10,000 grant from steel magnate Andrew Carnegie helped complete a substantial new library building. (Author's collection.)

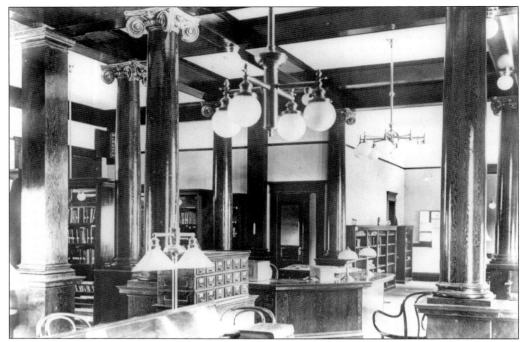

ORANGE PUBLIC LIBRARY INTERIOR, C. 1920. While the building was a gift from Andrew Carnegie, the community had to agree to furnish and maintain the library in proper style. (Orange Public Library.)

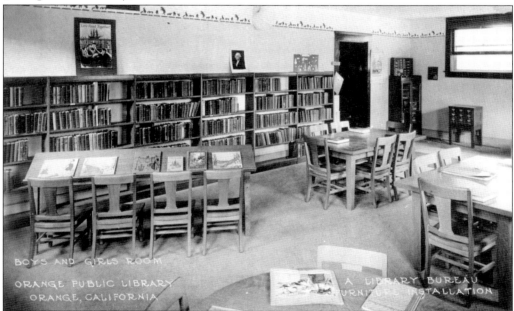

BOYS AND GIRLS ROOM, ORANGE PUBLIC LIBRARY, C. 1925. Orange's Carnegie library closed at the end of 1959, and a new building opened on the site in 1961. From 2005 to 2007, the building was completely remodeled and expanded, reopening as the Orange Public Library and History Center. (Tom Pulley.)

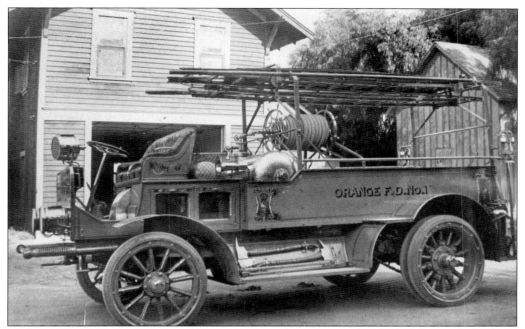

ORANGE VOLUNTEER FIRE DEPARTMENT, 1912. Orange's original volunteer fire department began in 1905. In 1912, they purchased their first motorized fire truck—a brand new Seagraves pumper—which they posed proudly in front of at the fire hall at 122 South Olive Street. Both the truck and the building are now long gone. (Orange Public Library.)

CALIFORNIA DIVISION OF FORESTRY HEADQUARTERS, 1950. Originally built in the 1930s at 1212 East Chapman Avenue, the Orange station served as the California Division of Forestry (CDF) headquarters for all of Orange County. Ranger Joe Scherman was in charge of county operations from 1930 to 1963. (Old Courthouse Museum, Geivet Collection.)

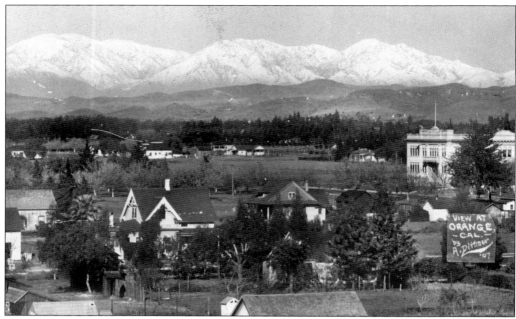

Winter in Orange, 1907. Local photographer Adolph Dittmer loved climbing up high to take sweeping panoramas of downtown. This view of the San Gabriel Mountains faces northeast from the tower of the Hotel Rochester. The original building for Orange Union High School is on the right. (Tom Pulley.)

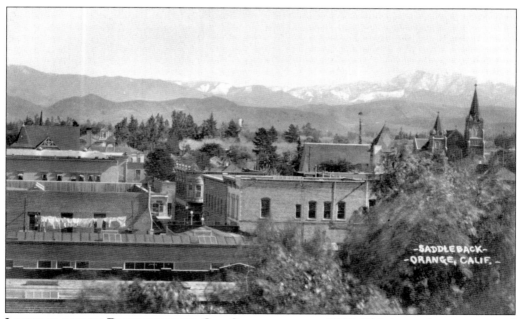

Looking across Downtown to Old Saddleback, c. 1922. This is another snowcapped mountain panorama from the top of the Hotel Rochester, this time looking east to Old Saddleback and the Santa Ana Mountains. (Tom Pulley.)

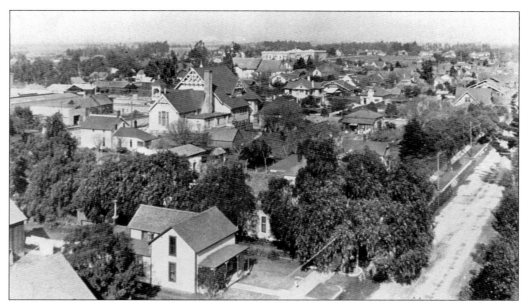

LOOKING NORTHWEST FROM THE TOWER OF ST. JOHN'S LUTHERAN CHURCH, C. 1914. The houses in the foreground, along with the First Christian Church, were eventually removed to make way for the Orange Civic Center. (Orange Public Library.)

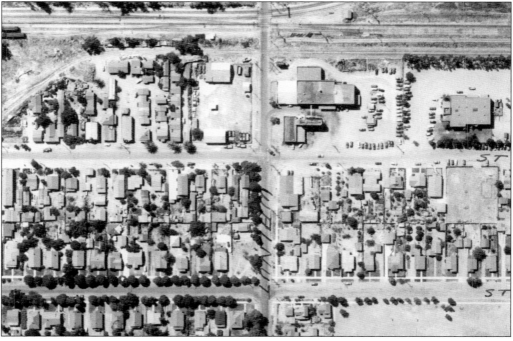

PORTION OF THE CYPRESS BARRIO, 1947. Beginning around 1900, Orange's first Mexican-American barrio began to take shape along North Cypress Street, near the packinghouses. In this view, Walnut Avenue cuts through the center, with the railroad on the west and Cypress Street just below it. In the upper right is the Cypress Street School, which operated as a segregated school from 1931 to 1944. (Orange County Archives.)

EAST CHAPMAN AVENUE, C. 1935. This image is looking west from just east of Cambridge Street in the 1930s, when East Chapman Avenue was lined with fine homes and large trees. Most of the homes that have survived were later converted into businesses. (Tom Pulley.)

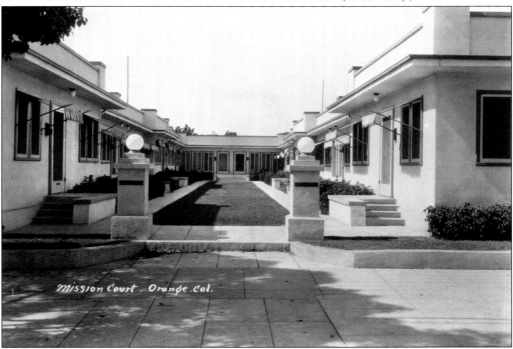

MISSION COURT, 1940. In the 1920s, courts—small clusters of apartments built around a central courtyard—were popular in Southern California. The Mission Court was built in 1920–1921 at 335 East Chapman Avenue. Later the site of the Bank of America, today the location is a part of the parking lot for the Orange Public Library. (First American Corporation.)

EAST PALMYRA AVENUE, C. 1910. With the many beautiful trees that line the streets of Orange today, it is hard to imagine that before the town was founded, there was hardly a single tree in the area except for a few sycamores along Santiago Creek. This view seems to be at Grand Street, looking east. (Author's collection.)

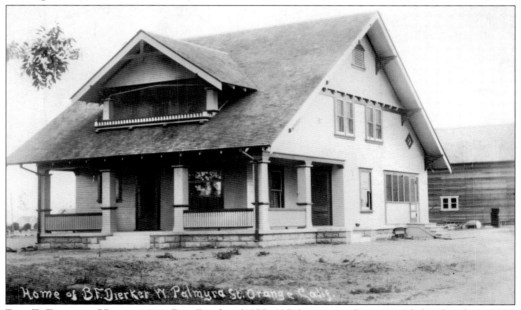

BEN F. DIERKER HOME, 1911. Ben Dierker (1877–1971) came to Orange with his family in 1892 and built this home at 705 West Palmyra Avenue in 1911 on his 10-acre citrus ranch. The two-story, 10-room, craftsman-style home was described as "one of the showplaces of the county." Dierker was well known in town as a city councilman in the 1930s and then as city park superintendent until 1944. His home no longer stands. (Tom Pulley.)

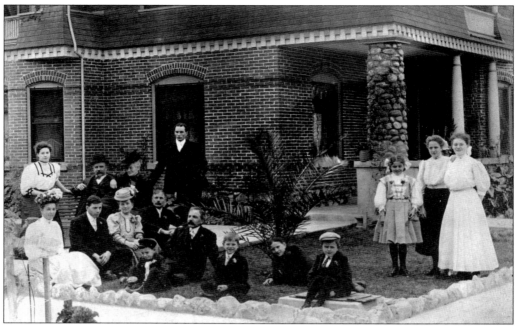

GUNTHER FAMILY HOME, C. 1906. Louis Gunther and his family gathered on the lawn of their new home at 206 West Almond Avenue shortly after its completion. Gunther, seated at left in the bowler hat, was a masonry contractor, and probably did much of the construction work himself. The Gunthers were one of a number of German Lutheran families who came to Orange in the early 1900s from Fort Dodge, Iowa. (Author's collection.)

NORTH HARWOOD STREET, 1927. In the 1920s, Mediterranean-style homes became more and more popular in Southern California. In Orange, many of them were modest, middle-class homes, which filled block after block of downtown. (Orange County Archives.)

Three

AGRICULTURE
AND INDUSTRY

Agriculture was the backbone of Orange's economy until the 1950s. The first important crops were wheat, barley, and raisin grapes. Other ranchers later met with success growing apricots, walnuts, avocados, and vegetables.

The first orange grove in Orange County was planted here in 1872, but oranges did not become the dominant crop until after the arrival of the railroad in the 1880s, when fresh fruit could be shipped across the country. Growers banded together to form cooperative packinghouses to handle their crop. The packinghouse associations then came together to form marketing organizations that touted their fruit across the nation.

The citrus industry provided work for hundreds of local residents. Unlike some other towns in the citrus belt, where a few large growers dominated the area, Orange grew into a middle-class community, with scores of small growers owning 10 or 20 acres of citrus.

But there was more to early Orange than just farming. After a few clumsy attempts, in the 1920s, industry found a foothold. Anaconda Wire and Cable, Great Western Cordage, and other manufacturing plants sprang up along the railroad.

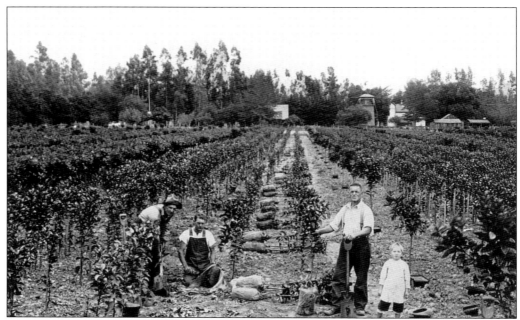

SETTING OUT ORANGE TREES, C. 1913. Orange trees were raised from seed, then set out in nursery rows, as shown here. Sweet varieties of oranges were grafted onto the "sour" rootstock in the groves, which was more resistant to disease. (University of California, Irvine, Don Meadows Collection.)

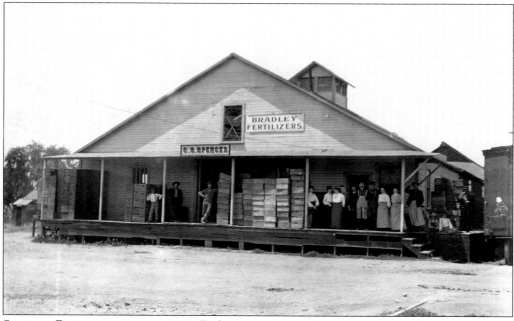

SPENCER PACKINGHOUSE, C. 1900. Early orange growers had to pack and sell their own fruit. Others sold their crop on contract to commission agents representing big wholesalers. The first packinghouses in Orange were private firms, like C. S. Spencer's packinghouse along the railroad tracks on West Chapman Avenue. (Gladys Reeves.)

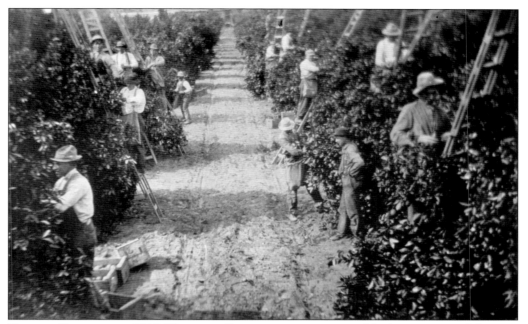

PICKING ORANGES, C. 1915. The start of harvest season was one of the busiest times of the year. Valencia oranges, the most popular variety here, usually ripened in May and with care, growers could still be picking fruit in October. Here workers climb into the trees on the Pierce Ranch on La Veta Avenue. (Orange Public Library.)

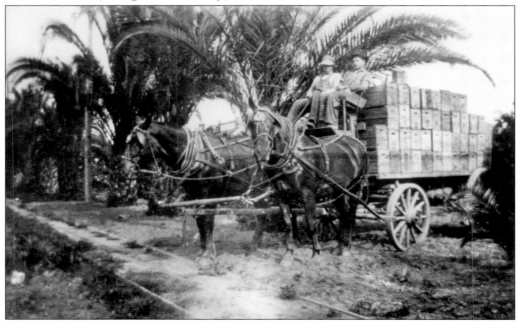

HAULING ORANGES, C. 1915. Horse-drawn wagons like this one on the Pierce Ranch were still used in the groves long after trucks became available, because there was less chance of them damaging the roots of the trees. The tracks in the foreground were from the old Santa Ana–Orange streetcar. (Orange Public Library.)

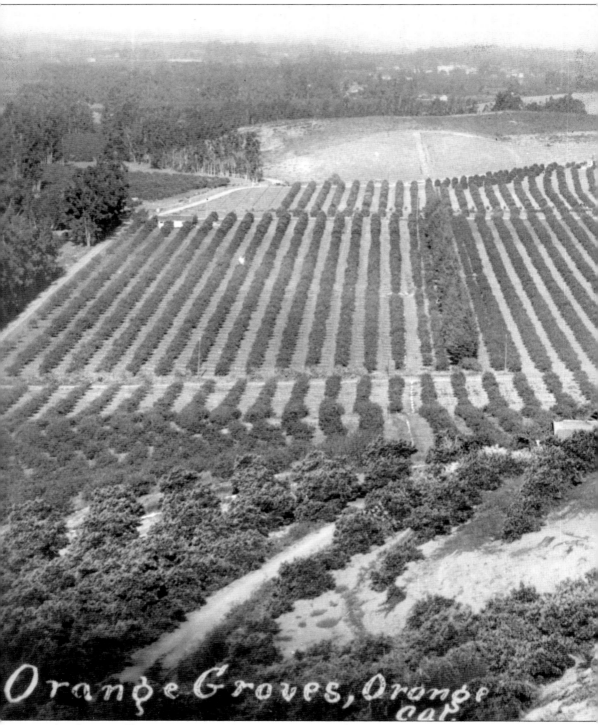

Orange Groves, Orange Cal.

AN ORANGE EMPIRE, C. 1920. Orange trees sweep along the foothills southeast of Orange.
At the peak of the citrus industry, there were more than 67,000 acres of orange groves in

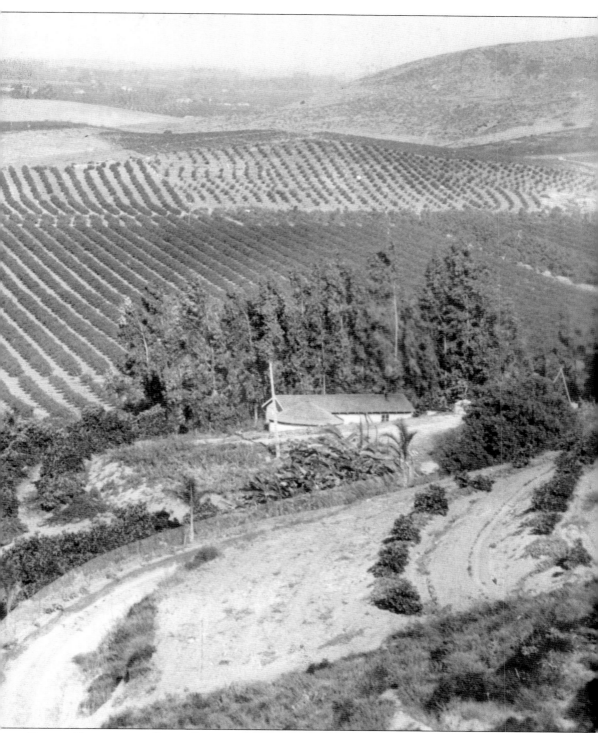

Orange County, some five million trees. (Tom Pulley.)

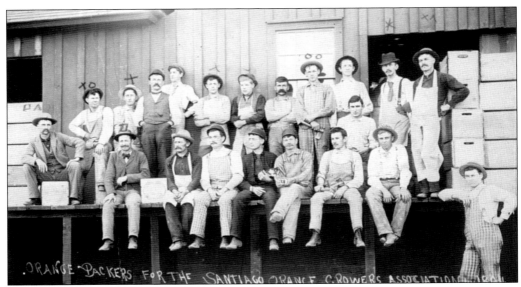

SANTIAGO ORANGE GROWERS ASSOCIATION PACKING CREW, C. 1894. Local growers eventually grew unhappy with commission agents and private packinghouses and began forming their own cooperative packinghouses. The Santiago Orange Growers Association was the first cooperative packinghouse in Orange, founded in 1893. E. T. Parker, their first manager, is posing on the left with his first packing crew. (University of California, Irvine, Don Meadows Collection.)

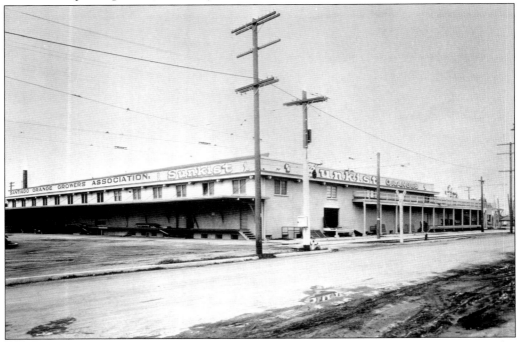

SANTIAGO ORANGE GROWERS ASSOCIATION PACKINGHOUSE, C. 1925. In 1918, the Santiago Orange Growers Association (SOGA) built a substantial packinghouse on North Cypress Street. The association grew to be the largest Valencia packinghouse in the nation. (First American Corporation.)

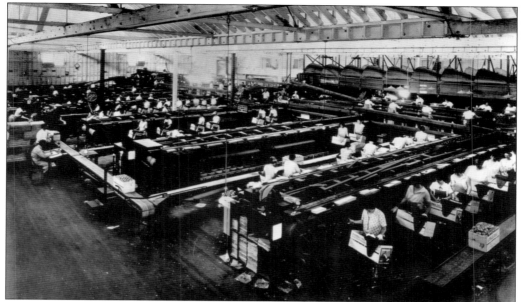

SANTIAGO ORANGE GROWERS ASSOCIATION PACKING OPERATIONS, 1932. Fruit arriving at the packinghouse was washed, graded, packed, cooled, and shipped by rail. After SOGA's demise in 1967, the old packinghouse was taken over by the Villa Park Orchards Association, which operated it until 2006. It was Orange County's last citrus packinghouse to close. Today the property is owned by Chapman University and the old plant is rented out to pack avocados. (Author's collection.)

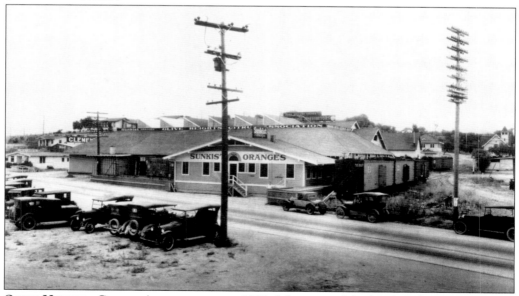

OLIVE HEIGHTS CITRUS ASSOCIATION, C. 1922. Like most of the local packinghouses, Olive Heights was a member of the Southern California Fruit Exchange, better known by their trademark, Sunkist. Founded in 1914, their first packinghouse, shown here, burned in 1927. The new packinghouse operated until 1984. In 1988, it also burned and was torn down a few years later. (First American Corporation.)

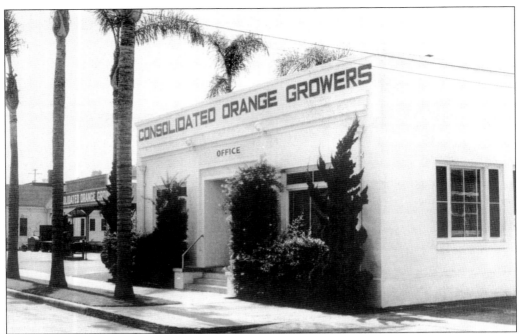

CONSOLIDATED ORANGE GROWERS OFFICE, C. 1950. Formed in 1928 by the merger of the McPherson Heights Citrus Association and the Red Fox Orchards, Consolidated Orange Growers soon abandoned the McPherson packinghouse and consolidated their operations at the old Red Fox Orchards packinghouse on South Cypress Street. (First American Corporation.)

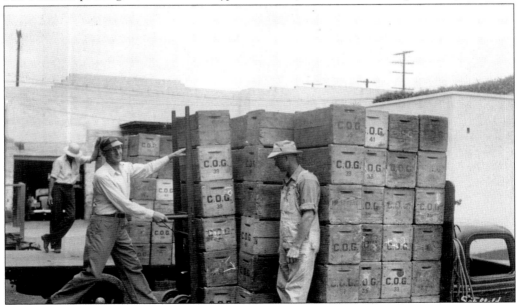

UNLOADING TRUCKS, CONSOLIDATED ORANGE GROWERS, C. 1938. Consolidated Orange Growers continued to pack fruit until 1965, when they merged with the Olive Heights Citrus Association. The old packinghouse building still stands. It is the oldest wooden packinghouse in Orange County. (Tom Pulley.)

JIM DANDY LABEL, 1932. Orange boxes shipped with large, colorful labels on the ends to make the fruit easier to spot at large wholesale auction houses. Buyers knew which brands were the top grade from each packinghouse and which were merely "orchard run," the lowest grade of fruit. (Author's collection.)

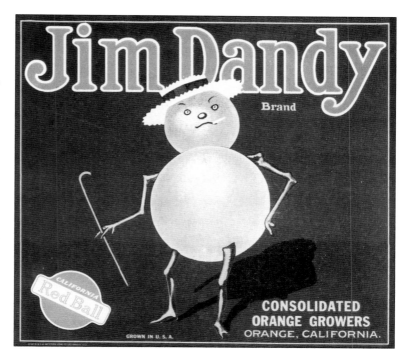

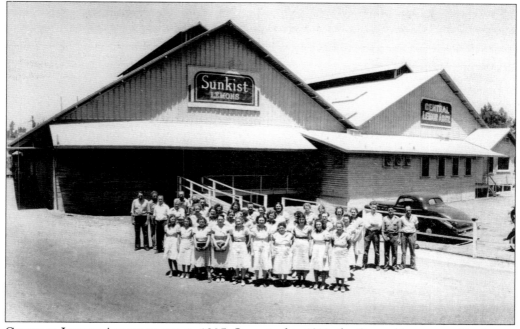

CENTRAL LEMON ASSOCIATION, C. 1935. Organized in 1912, the Central Lemon packinghouse was located along the railroad between Orange and Villa Park, near what is now the northeast corner of Wanda and Villa Park roads. Once touted as the largest lemon packinghouse in the nation, the members voted to dissolve the association in 1960 as citrus acreage disappeared under miles of tract housing. (First American Corporation.)

MCPHERSON HEIGHTS CITRUS ASSOCIATION, 1951. Incorporated in 1912, the McPherson Heights packinghouse was located along McPherson Road at Chapman Avenue. The packinghouse was used for only a few years after the association combined with Red Fox Orchards in 1928 to form the Consolidated Orange Growers. By the time Weldon Field took this photograph, it was in sad shape. The old packinghouse was torn down just a few years later. (Orange Public Library.)

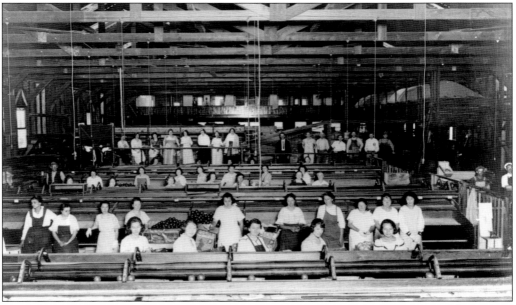

INSIDE THE MCPHERSON HEIGHTS CITRUS ASSOCIATION PACKINGHOUSE, 1924. The women in the foreground are wrapping the fruit in tissue and packing it in wooden boxes. They are packing the William Tell brand. Many of the packinghouses used similar themes in their labels; for McPherson, it was archers. Their other brands included Robin Hood, Mohican, and Bow-Man. (Orange Public Library.)

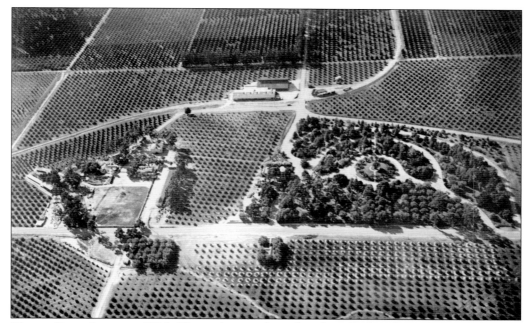

HEWES PARK AREA, C. 1920. The park is on the right, along Esplanade, and La Veta Avenue comes down from the top, curving past the Hewes packinghouse. A Southern Pacific branch line connected the packinghouses in Villa Park, McPherson, and El Modena by rail. (First American Corporation.)

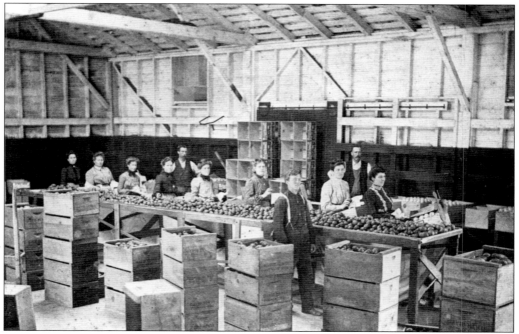

HEWES PACKINGHOUSE INTERIOR, C. 1903. A far cry from the sophisticated packing equipment of later years, workers in the Hewes packinghouse simply graded and sized the fruit off of the long tables by eye. The Hewes packinghouse burned down in 1947. (First American Corporation.)

JOSEPH YOUNG HOME AND WINERY, C. 1896. While Anaheim was better known for its wineries, there were also several in the Santa Ana and Orange areas. Young's was located along Fairhaven Avenue, at what is now Linwood Street. It operated from 1876 until 1911. The house (much remodeled) still stands. (Mark Hall-Patton.)

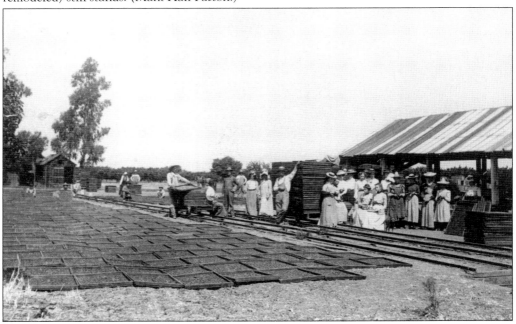

APRICOT CAMP ON THE CRAWFORD RANCH, C. 1905. Apricots were a popular crop in the years before World War I. Most were dried for shipment across the nation, and even to Europe. For a few weeks each summer, the apricot camps were a bustle of activity and provided employment for hundreds of local residents. The Crawford Ranch was located on the east side of Santiago Boulevard, between Taft and Meats Avenues. (University of California, Irvine, Don Meadows Collection.)

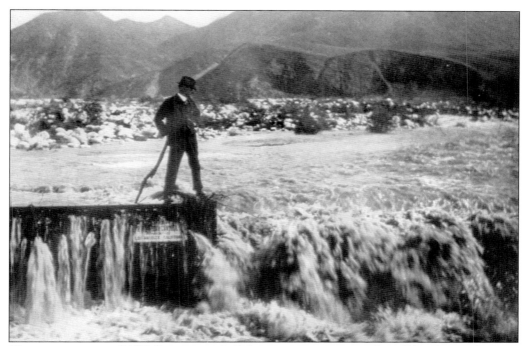

HEADGATE ON THE SAVI CANAL, C. 1915. Irrigation water was vital to all local agriculture. In 1877, local ranchers formed the Santa Ana Valley Irrigation Company (SAVI), which built an extensive series of canals, pipes, and tunnels beginning on the Santa Ana River far up the canyon at Bedrock Crossing. The SAVI continued to deliver irrigation water until 1974. (Duncan Clark.)

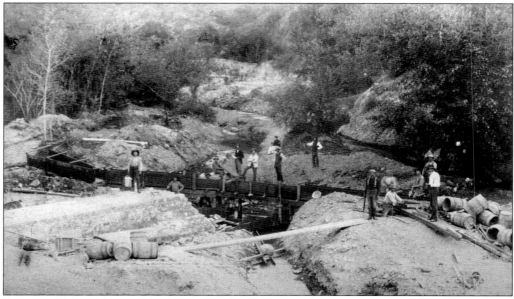

SUBMERGED DAM CONSTRUCTION, 1892. Ranchers east of Orange tapped the Santiago Creek for water. To force more flow to the surface, in 1879 they built a "submerged" dam down into the creek bed. The first dam was of clay, but it was replaced in 1892 by a concrete dam, which still stands in the Santiago Oaks Regional Park. (University of California, Irvine, Don Meadows Collection.)

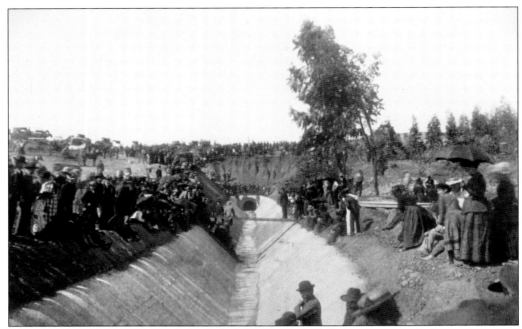

SAVI TUNNEL DEDICATION AT OLIVE, 1892. To improve the flow in their canals, during 1877–1878 the Santa Ana Valley Irrigation Company dug two tunnels more than 900 feet through the hills at Olive. They were further improved in 1892, when the company lined them with concrete. The mouth of the tunnel was near the top of today's Eisenhower Park. (University of California, Irvine, Don Meadows Collection.)

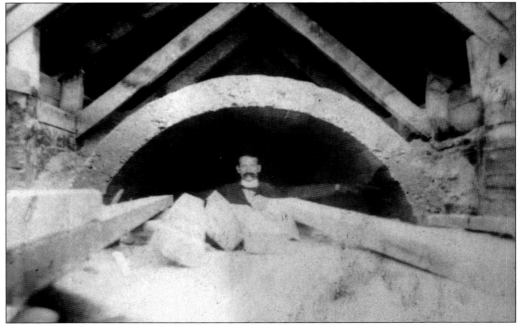

SAVI TUNNEL COLLAPSE, C. 1900. The size of the tunnels is evident in this photograph, taken after a small collapse in one of the tunnels. (Duncan Clark.)

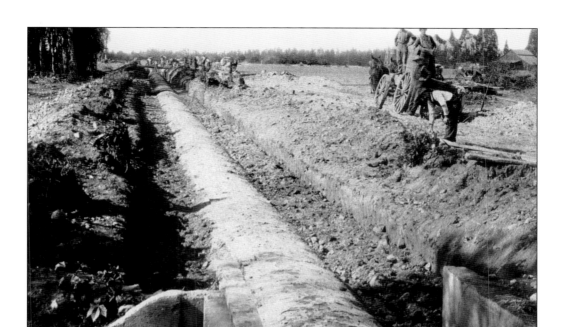

REPLACING OPEN DITCHES WITH CONCRETE PIPE, C. 1910. The original SAVI system relied on earthen ditches that lost a great deal of water through seepage. Over the years, the old, open ditches were replaced by concrete pipe, which were poured in place. The crew shown here was at work near Olive. (Ethel Burnette.)

ORANGE'S FIRST FACTORY. Despite its reputation for agriculture, Orange had several factories in the early days. The first was the Modern Machine Manufacturing Company (better known to the old-timers as the Razor Factory), which was built in 1908 at 512 West Chapman Avenue. After the razor project went bust, the plant was renovated in 1916 to make a breakfast cereal called Fig-Nuts. The old building was finally razed in 1989, shortly after this photograph was taken. (Author's collection.)

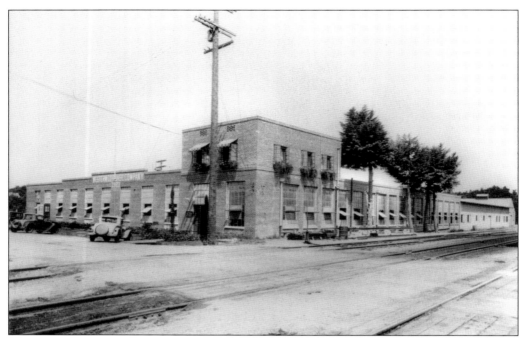

WESTERN CORDAGE COMPANY, C. 1930. Rope making was another early Orange industry. Western Cordage Company, founded in 1923, built their factory along Palm Avenue on the Santa Fe Railroad. (First American Corporation.)

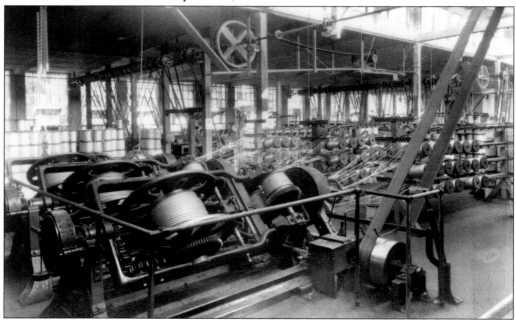

SPINNING ROPE, GREAT WESTERN CORDAGE COMPANY, 1936. Clarence Jordan bought a controlling interest in the company in 1928 and added "Great" to its name. Later the company was known as Tubbs Cordage. The plant finally closed in 1987, but the building still stands. (Carol Jordan.)

Four

Churches, Schools, and Civic Organizations

As communities grow, institutions grow with them. Schools gave communities an identity and were a source of civic pride. In many smaller communities, the schoolhouse was the biggest building in town. Orange got its first elementary school in 1872, just six months after the town was founded, and Orange Union High School (founded in 1903) helped draw together the smaller surrounding communities.

Churches were also seen as a necessity in the early days and helped to bring families to the community. The Methodists were the first denomination to establish a church in Orange in 1873, and St. John's Lutheran Church (founded in 1882) lured many German families to town.

Civic organizations also played a role in Orange's development. When the town was founded, fraternal organizations such as the Odd Fellows and the Masons were prominent, but after World War I, civic groups such as the Rotary Club and the chamber of commerce grew in importance. About that same time, youth groups such as the Boy Scouts and the YWCA also began to take hold.

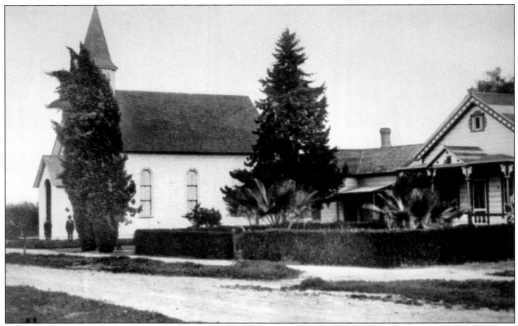

ORANGE METHODIST EPISCOPAL CHURCH, C. 1890. The first congregation organized in Orange in 1873, the Methodists built the first church in town in 1875. They continue today as the First United Methodist Church of Orange, in a new sanctuary built on the original site. (First United Methodist Church of Orange.)

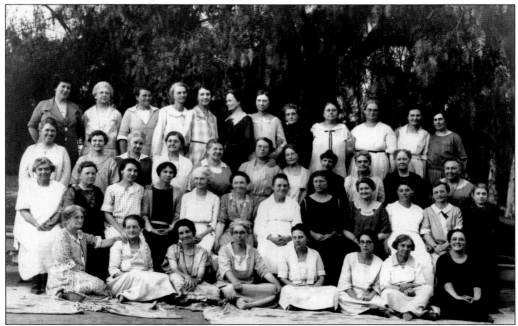

METHODIST SOUL WINNERS CLASS, 1924. Adult Sunday school classes were common in the early days, and the ladies' Soul Winners class was one of several active at the Methodist Church in the 1920s. (Author's collection.)

ORANGE METHODIST CHURCH, C. 1949. A new sanctuary and tower was completed in 1907, but the 1875 church is still visible on right. Both were razed in 1958 to make way for the present sanctuary. (Author's collection.)

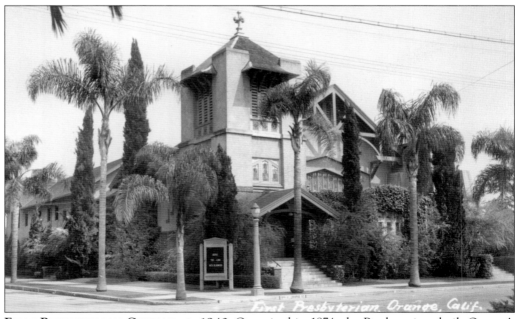

FIRST PRESBYTERIAN CHURCH, C. 1940. Organized in 1874, the Presbyterians built Orange's second church on the present site in 1881. It was replaced in 1912 by this sanctuary, which was in use until 1965. (Tom Pulley.)

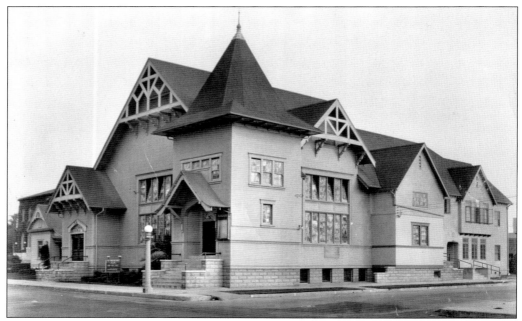

FIRST CHRISTIAN CHURCH, 1929. Founded in 1883, the Christian Church was located on the southeast corner of Chapman Avenue and Grand Street from 1887 to 1961 when it was razed to make way for the Orange Civic Center. The sanctuary was remodeled several times over the years. This photograph was taken just after the new education building on the right had been completed. (Author's collection.)

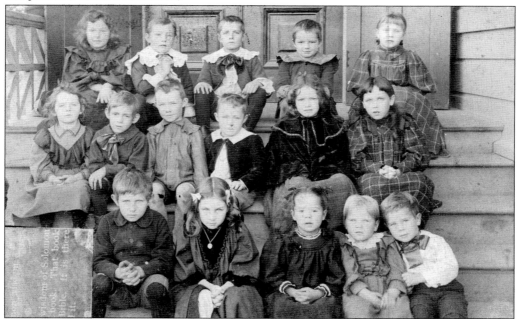

FIRST CHRISTIAN SUNDAY SCHOOL, C. 1898. A children's Sunday school class poses on the steps of the First Christian Church. The congregation is still active today at a new location. (Orange County Archives.)

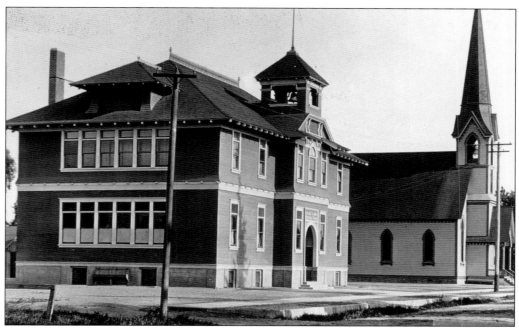

ST. JOHN'S LUTHERAN CHURCH AND SCHOOL, 1907. Founded in 1882, St. John's would play an important role in the development of Orange, attracting many German families to the area. On the right is the church, built in 1893 at the northeast corner of Olive Street and Almond Avenue. On the left is the school, built in 1904. (Orange Public Library.)

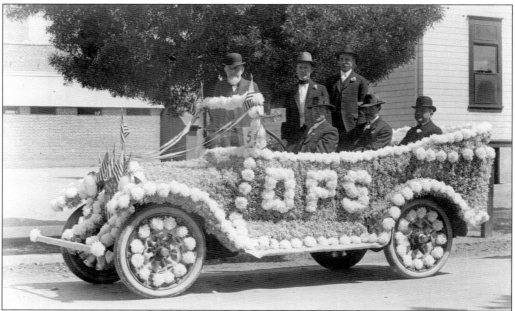

ST. JOHN'S LUTHERAN LEADERS ON PARADE, 1917. Founding pastor Jacob Kogler is standing on the left. He retired that same year after 35 years of service. Standing on the right is William. Batterman, the longtime principal of what was then known as the Orange Parochial School. Carl Jorn is behind the wheel of his flower-decorated car. (Tom Pulley.)

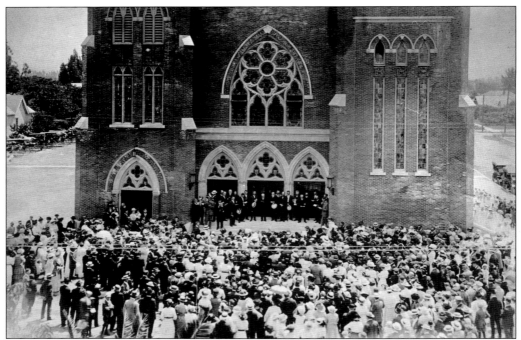

DEDICATION OF ST. JOHN'S LUTHERAN CHURCH, 1914. In 1913, St. John's began construction of their present sanctuary. It was dedicated on July 19, 1914, before a large crowd. The Gothic-style church remains a local landmark. (First American Corporation.)

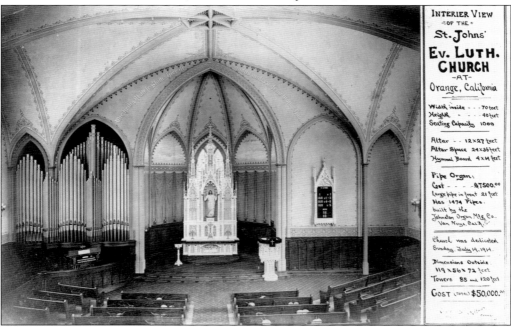

INTERIOR, ST. JOHN'S LUTHERAN CHURCH, 1914. The interior of the new St. John's Lutheran was equally striking. This souvenir postcard was published by local photographer Adolph Dittmer, a member of the congregation, in honor of its dedication. (Tom Pulley.)

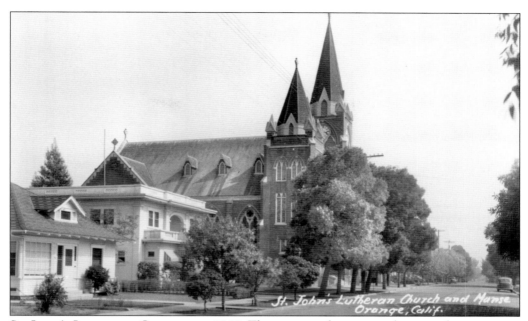

ST. JOHN'S LUTHERAN CHURCH, C. 1940. The two-story home next door was the parsonage, built in 1921. (Tom Pulley.)

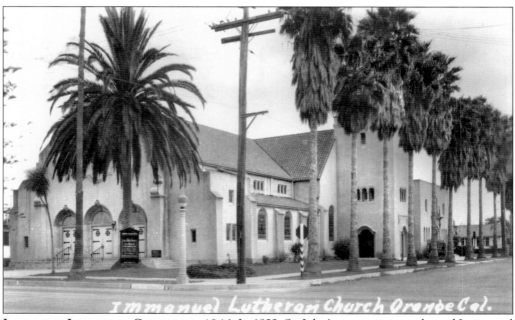

IMMANUEL LUTHERAN CHURCH, C. 1946. In 1922, St. John's congregation split and Immanuel Lutheran Church was born. The new church built this fine Mediterranean-style sanctuary in 1923 where they still worship to this day. (Author's collection.)

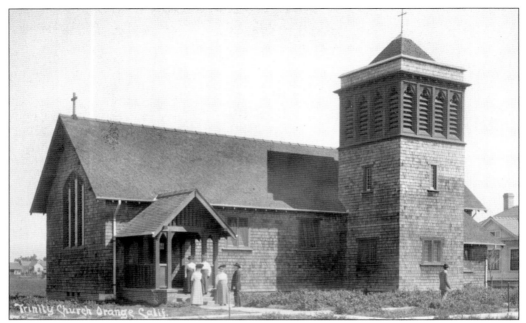

TRINITY EPISCOPAL CHURCH, C. 1910. The congregation began as a mission church in 1887 and built this shingled sanctuary in 1909 at the corner of Maple Avenue and Grand Street. It was designed by H. P. Frohman, who later served as resident architect of the National Cathedral in Washington, D.C. The congregation moved to their current home on Canal Street in 1971 and the old church served as the Chapman College Chapel for many years. (Author's collection.)

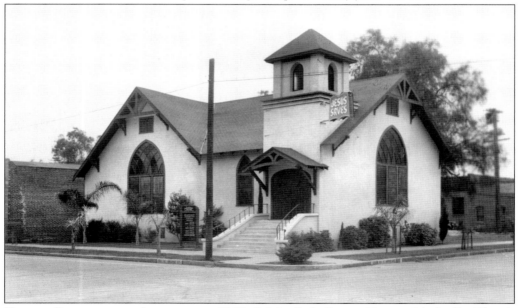

TRINITY PENTECOSTAL ASSEMBLY, C. 1940. Originally built as a German Methodist Church in 1911, the "Deutsche Methodisten Kirche" folded around 1936, and the Trinity Pentecostal Assembly—later known as the First Assembly of God—moved in. Located at the southwest corner of Orange Street and Maple Avenue, the old sanctuary stood until the 1960s. (Tom Pulley.)

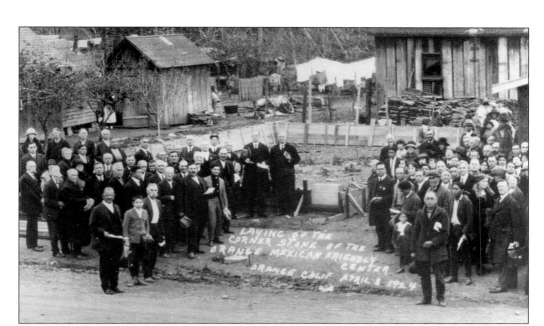

LAYING OF THE CORNERSTONE, THE FRIENDLY CENTER, 1924. Sponsored by the Men's Community Bible Class and several local churches (notably the Methodists), the Friendly Center was designed as a church and community center for the Mexican-American barrio on Cypress Street. Church services ended in the early 1950s, but the community center continues to this day. The original building was used until 1985. It still stands at 436 North Cypress Street. (The Friendly Center.)

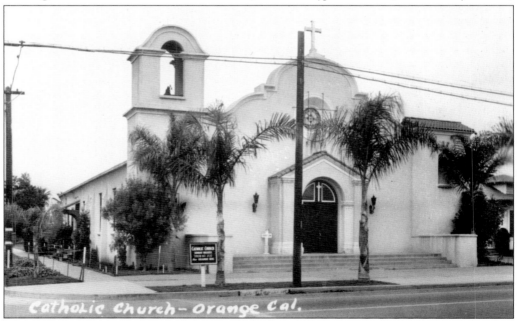

HOLY FAMILY CATHOLIC CHURCH, C. 1940. Orange's first Catholic parish, Holy Family was established in 1921. Their original sanctuary at the northeast corner of Chapman Avenue and Shaffer Street was remodeled in 1930 in the Romanesque Revival style with Spanish influences. The congregation moved to their present location in 1953. (Tom Pulley.)

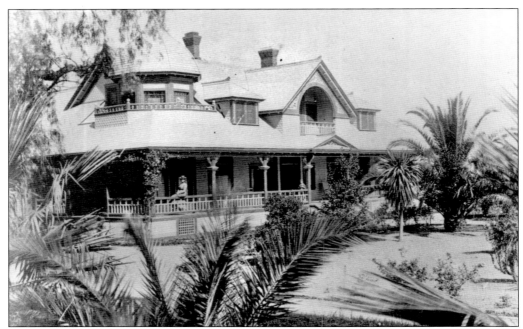

W. H. Burnham Mansion, c. 1900. In 1922, the sisters of Saint Joseph came to Orange, establishing their motherhouse in W. H. Burnham's old home on South Batavia Street. Built in 1893, the home was one of the showplaces of early Orange. It was razed in 1972. (Old Courthouse Museum.)

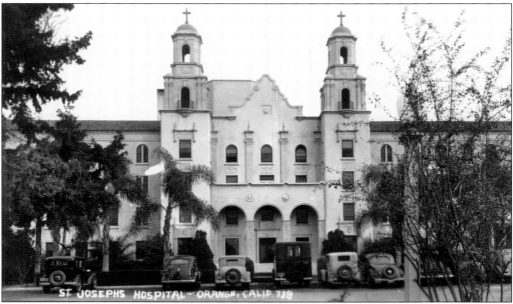

St. Joseph Hospital, 1937. Originally a teaching order, the sisters of Saint Joseph opened their first hospital in Eureka, California, during the influenza epidemic after World War I. In 1929, they opened Orange County's first modern hospital in Orange. Today St. Joseph Health System operates three hospitals in Orange County. (Tom Pulley.)

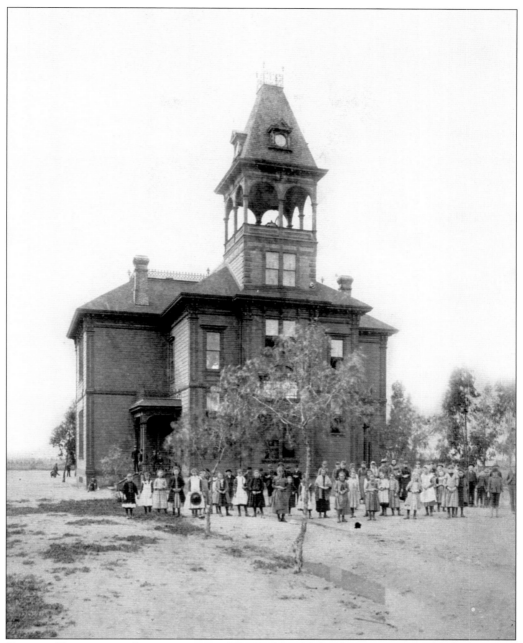

ORANGE ELEMENTARY SCHOOL, C. 1887. The Richland School District was established in 1872, just six months after the community was founded. This impressive schoolhouse was built in 1886 and was used until 1931. It stood on what is now the Chapman University law school campus. (University of California, Irvine, Don Meadows Collection.)

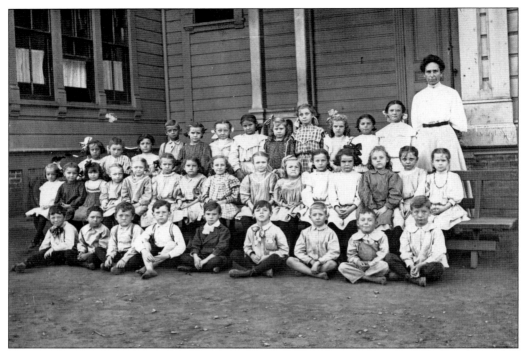

ORANGE ELEMENTARY SCHOOL STUDENTS, C. 1900. The 1887 school housed all eight grades. After other schools were built around town, it became known as the Lemon Street School. (Gladys Reeves.)

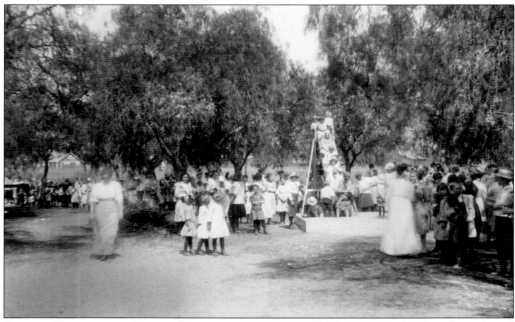

ORANGE ELEMENTARY SCHOOL PLAYGROUND, C. 1910. The downtown school yard was dotted with pepper trees, some dating back to the 1870s. The last survivors were cut down a few years ago. (Tom Pulley.)

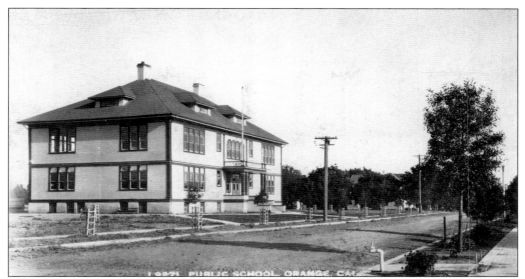

CENTER STREET SCHOOL, C. 1914. As Orange grew, new schools were added. The Center Street School opened in 1907 at the southeast corner of Center Street and Culver Avenue. It was the second elementary school within the city limits. (Tom Pulley.)

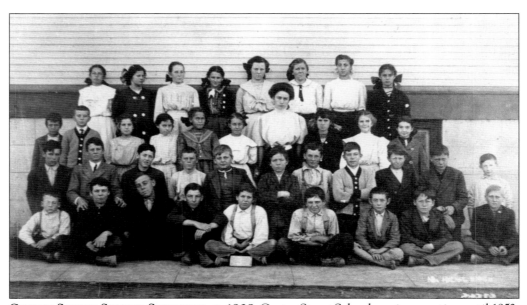

CENTER STREET SCHOOL STUDENTS, C. 1908. Center Street School was in operation until 1952, when Palmyra Elementary School opened. The old building was later razed and apartments now cover the site. (Ken Claypool.)

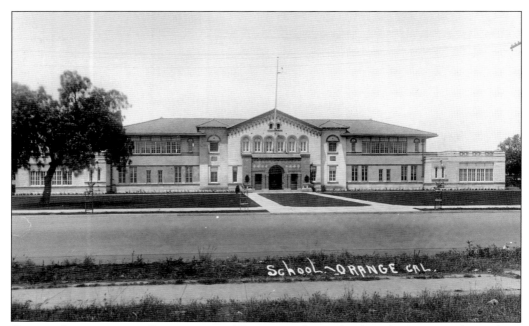

ORANGE INTERMEDIATE SCHOOL, 1914. The intermediate school was built in 1914 for students in grades seventh and eighth. It stood just in front of the 1887 Orange Elementary School, along North Glassell Street. (Tom Pulley.)

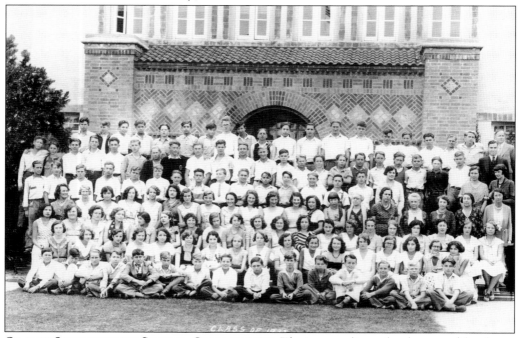

ORANGE INTERMEDIATE SCHOOL, CLASS OF 1932. The intermediate school was used for classes until Yorba Junior High School opened in 1957. It then housed the offices of the Orange Unified School District. Chapman University's law school preserves the facade of the old building as part of their new complex. (Author's collection.)

ORANGE UNION HIGH SCHOOL STUDENTS, C. 1904. In 1903, residents in the Orange, El Modena, Villa Park, and Olive School Districts voted to form the Orange Union High School District. The new school opened that fall in rented quarters in the Dobner Block on South Glassell Street. It can be seen here, on the right, in this rare, early photograph. (Dr. G. Abbott Smith.)

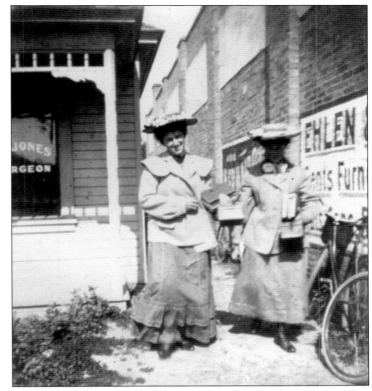

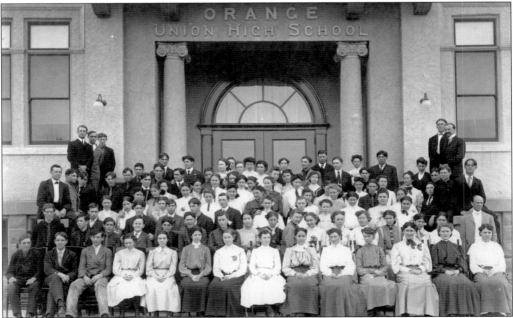

ORANGE UNION HIGH SCHOOL, 1905. The entire student body of Orange Union High School posed on the steps of their new building in 1905. Principal Charles E. Taylor is in the second row, on the right. (Author's collection.)

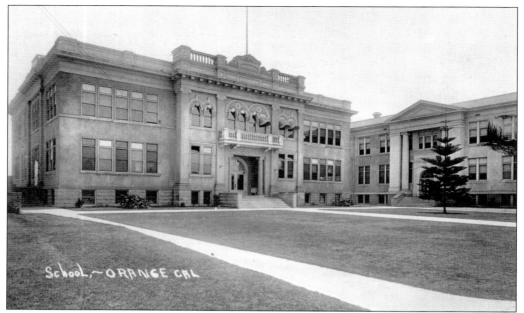

ORANGE UNION HIGH SCHOOL, C. 1915. The original building was joined in 1913 by two more buildings, the science and commercial buildings. Though later moved to make way for the auditorium, the original building still stands on the Chapman University campus. Today it is known as Wilkinson Hall. (Tom Pulley.)

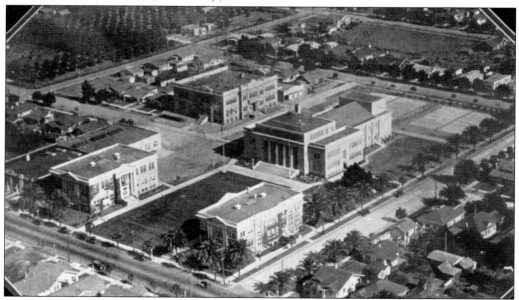

ORANGE UNION HIGH SCHOOL, C. 1924. By the mid-1920s, the campus had grown to include five buildings. The science and commercial buildings—jokingly known as the "Twins"—are on the left, along Glassell Street. Just to the north is the shop building. The new memorial auditorium is in the center, with the old academic building in its new location beyond it. All of these buildings still stand at Chapman University, which bought the old campus in 1954. (Orange High School collection.)

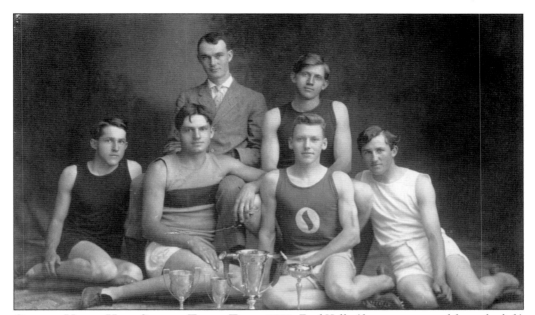

ORANGE UNION HIGH SCHOOL TRACK TEAM, 1911. Fred Kelly (front row, second from the left) was Orange High School's first star athlete, who later went on to win an Olympic gold medal in the high hurdles at the games in Stockholm in 1912. The Orange Unified School District stadium at El Modena High School is named in his honor. (Author's collection.)

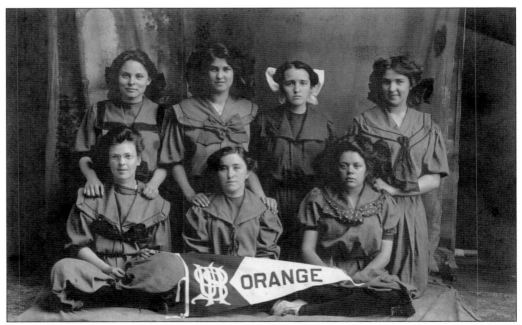

ORANGE UNION HIGH SCHOOL GIRLS' BASKETBALL TEAM, 1910. One of the few high school sports open to girls at the time, basketball was still played in cumbersome outfits. Florence Flippen Smiley, later one of the founders of the Orange Community Historical Society, is at the upper left. (Author's collection.)

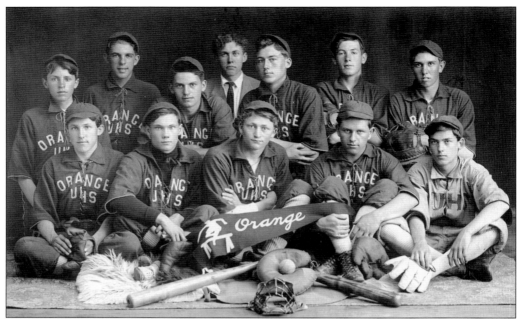

ORANGE UNION HIGH SCHOOL BASEBALL TEAM, 1911. Baseball was one of Orange High's early strengths. The school won championships in 1910, 1914, and 1916. (Author's collection.)

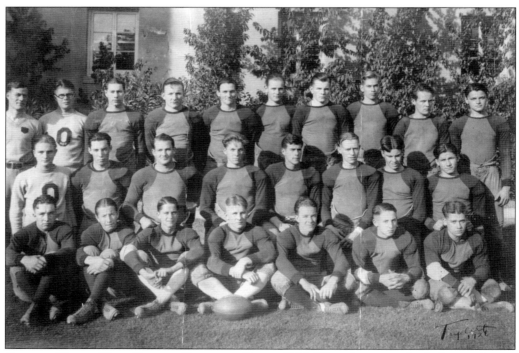

ORANGE UNION HIGH SCHOOL FOOTBALL TEAM, 1926. Though never a football powerhouse, Orange Union High School has fielded teams almost every year since 1903. The biggest game of the year was always against Santa Ana High School. (Author's collection.)

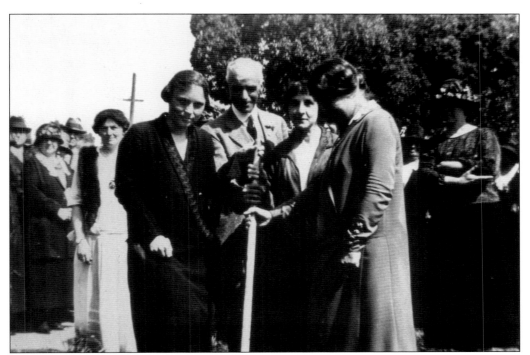

BREAKING GROUND FOR THE WOMAN'S CLUB OF ORANGE, 1924. Founded in 1915, the Woman's Club of Orange constructed its own building in 1924. Here past president Florence Flippen Smiley (left) joins former mayor Frank Ainsworth and other Woman's Club of Orange officials on the shovel. (Orange Public Library.)

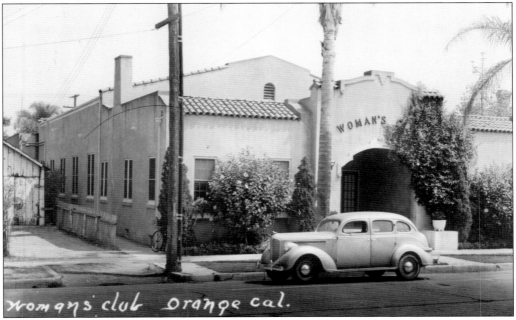

WOMAN'S CLUB OF ORANGE, C. 1945. The Woman's Club of Orange still occupies their original clubhouse and is one of the most active woman's clubs in Orange County. (Tom Pulley.)

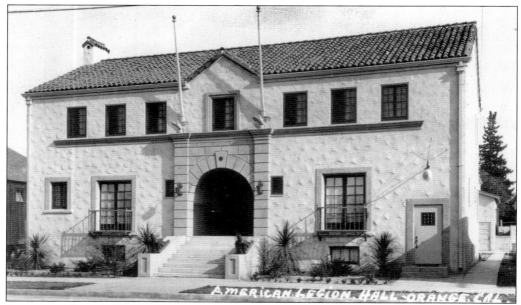

AMERICAN LEGION HALL, C. 1945. The Orange American Legion Post No. 132 was organized in 1919 by veterans returning home from World War I. In 1928, they built their own meeting hall on South Lemon Street. It is still in use. (Tom Pulley.)

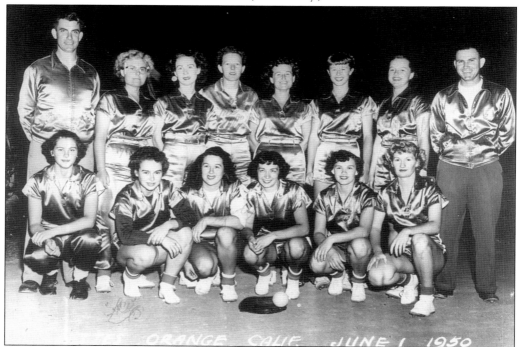

ORANGE LIONETTES, 1950. The Lions Club's best-remembered contribution to Orange was the founding of the Orange Lionettes in 1936. The women's softball team, in their orange satin uniforms, won many national championships over the years, starting with the 1950 World Series. Sponsored by others in later years, the Lionettes played until 1975. (Orange Public Library.)

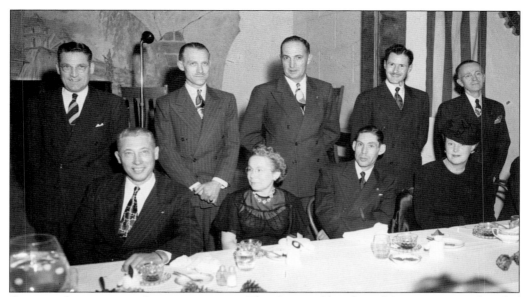

ORANGE CHAMBER OF COMMERCE, 1947. The Orange Chamber of Commerce was founded in 1921. At their annual dinner in January 1947, county surveyor W. K. Hillyard assured them, "There is no question of a population of 1,000,000 people for Orange County in 1970 or 1980." The county hit that mark in 1963. Seated at the head table are Pres. John T. McInnis and his wife (to his left) and past president Robert Wheeler and his wife. (Old Courthouse Museum, Geivet Collection.)

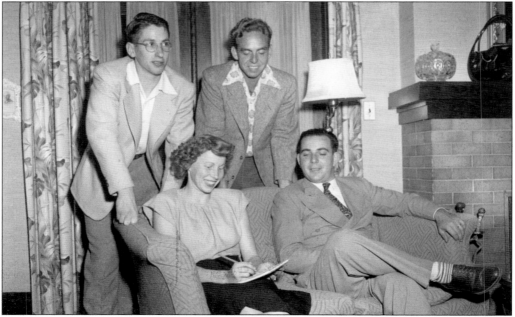

ORANGE YOUNG REPUBLICANS, 1947. The newly formed Orange Young Republicans included David and Frieda Hart (left), Pres. Larry Nichols (seated, right), and James Daum. For years, Orange was one of the most Republican towns in one of the most Republican counties in California. (Old Courthouse Museum, Geivet Collection.)

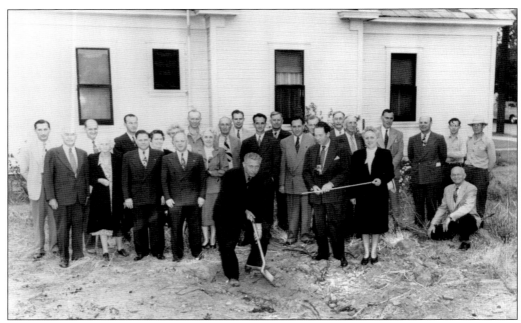

BREAKING GROUND FOR ORANGE YMCA/YWCA, 1948. Built jointly by the local YMCA and YWCA, the $100,000 clubhouse on North Grand Street served both organizations until 1973 when the YMCA moved to their current facilities. The YWCA owned the old building until 2005, when it was sold to the First Presbyterian Church. Longtime YMCA/YWCA supporter John T. McInnis is doing the honors with the shovel before a crowd of community officials. (Orange Public Library.)

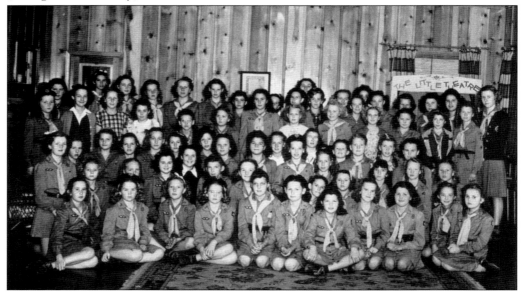

GIRL SCOUT GATHERING, 1945. Some 150 local girls gathered at the Girl Scout House on Toluca Avenue in March 1945 to mark the 33rd anniversary of the Girl Scouts of America. The local council was founded in 1927 and merged into the new Santiago Council in 1959. (Marjorie Sherrill.)

Five

NEIGHBORING
COMMUNITIES

As the city of Orange grew, it took in several smaller neighboring communities. Some retained part of their old identity, while others have been almost completely forgotten.

Outside of San Juan Capistrano, Olive is the oldest community in Orange County. Beginning around 1810, it was the home of the Yorba family, owners of the Rancho Santiago de Santa Ana. In 1887, a town site was laid out on the hill. Below Olive was the short-lived town of St. James, which lived and died with the railroad boom of the 1880s.

El Modena was founded in 1886 and had a large Quaker population in the early days. As the citrus industry grew in the early 1900s, the area became home to many Mexican families, who found work in local orchards. To the east, the little town of McPherson grew up around the McPherson brothers' vineyards. In 1886, the brothers laid out a town site on the north side of Chapman Avenue, at McPherson Road, but a blight struck the local vineyards soon after the town was founded and McPherson eventually faded away.

West Orange was a farming community, without any businesses, but it did have its own school and a station on the Southern Pacific Railroad, near where Flower Street meets La Veta Avenue. In 1914, the state highway cut through West Orange, heading east on Chapman Avenue and then south on Main Street. A little business district soon grew up on the corner, known as Orana, since it was midway between Orange and Santa Ana.

Orange Park Acres was laid out in 1928 as a ranching and citrus-growing community. Some of the area still remains as unincorporated county territory. It is now completely surrounded by the city of Orange. South of Orange Park Acres, Orange has spread out into Peters Canyon, or Santiago Hills as it is now known. North of Villa Park, which was incorporated as a separate city in 1962, Orange now runs up into the hills at Serrano Heights.

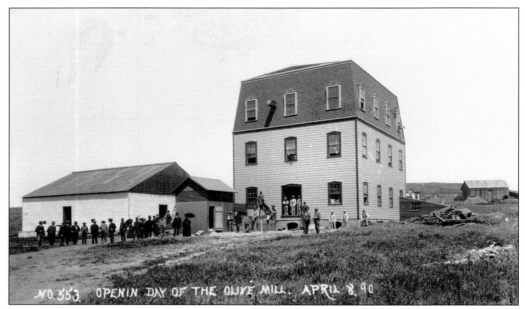

OPENING OF THE SECOND OLIVE MILL, 1890. The little town of Olive first gained fame in the 1880s as the site of Orange County's largest flour mill. The original mill was built in 1882 and burned down seven years later. It was replaced by this mill, which opened in 1890 and stood until 1932. It was located at what is now the corner of Lincoln and Ocean View Avenue, near Eisenhower Park. (California State University, Fullerton, Special Collections.)

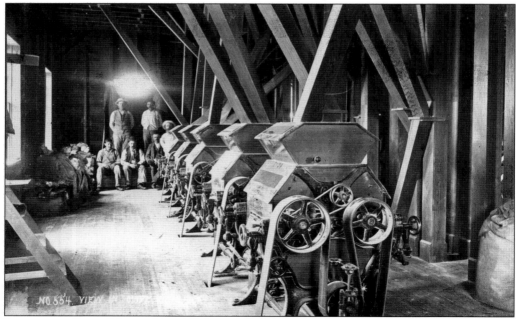

INSIDE THE OLIVE MILL, 1890. All the machinery in the mill, including these five rollers, was operated by waterpower. Irrigation water from the SAVI tunnels dropped about 45 feet into their main canal, providing more than enough power for the mill's turbine. (California State University, Fullerton, Special Collections.)

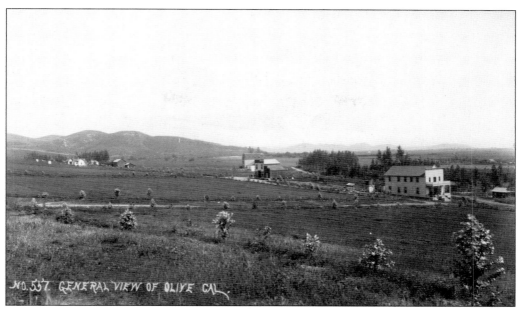

LOOKING SOUTHEAST ACROSS OLIVE, 1890. The road curving along on the right was Hope Street, which is now Lincoln Avenue. Louis Schorn's two-story Olive Heights Hotel is on the right and the second Olive Mill is visible in the distance. (California State University, Fullerton, Special Collections.)

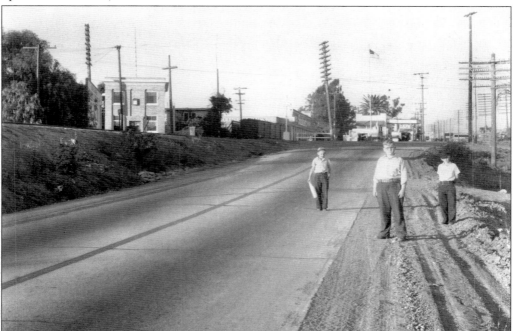

ORANGE-OLIVE ROAD, 1931. At the upper left, on Lincoln Avenue, is the two-story First National Bank of Olive, organized in 1916 at a time when many small communities had their own local bank. Olive's bank did not survive the Depression, and by 1933, it was closed for good. (Old Courthouse Museum.)

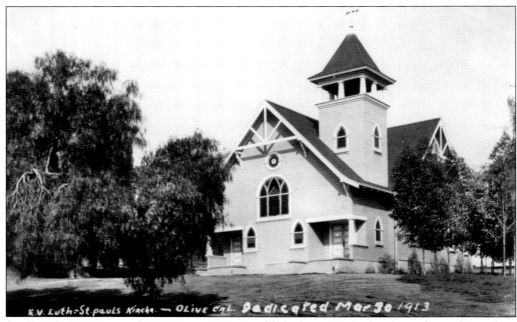

ST. PAUL'S LUTHERAN CHURCH, C. 1913. Established in 1907 by local members of St. John's Lutheran Church, St. Paul's dedicated this fine sanctuary in 1913. Like St. John's and Immanuel Lutheran, they also operate their own parochial school. The congregation moved to its present location in 1963, and the old church is now a part of the North Orange Christian Church complex. (Tom Pulley.)

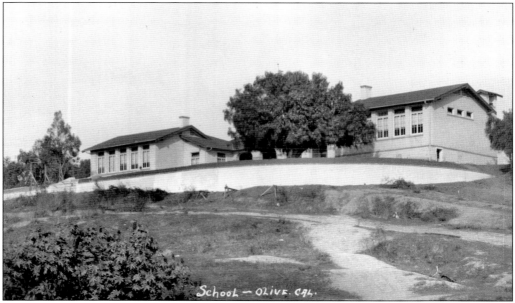

OLIVE ELEMENTARY SCHOOL, C. 1925. The Olive Elementary School District was established in 1876 and gave the community its name. Originally located down on the flats, the school moved to its present location in 1895. This Mediterranean-style campus was built in 1919 and was in use until the 1960s. (Tom Pulley.)

St. James Tract Map, 1887. During the railroad boom of the 1880s, some of the owners of the Santa Fe Railroad established their own real estate development company, the Pacific Land Improvement Company, which laid a number of new towns along the tracks. St. James was centered along what is now Orange-Olive Road, near Heim Avenue (today's St. James Avenue would be near the northern end of the tract). Like many of the boomtowns, St. James did not survive. (Orange County Archives.)

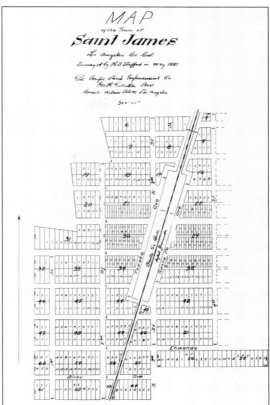

Hamilton's Livery, Moved from St. James, c. 1890. Some of the buildings from St. James were later moved to Orange. After his livery stable on North Glassell Street burned in 1888, A. S. Hamilton moved one down as a replacement. Later moved to the back of the lot as a warehouse for the Kogler Hardware Company, it was not torn down until 1953. (Orange Public Library.)

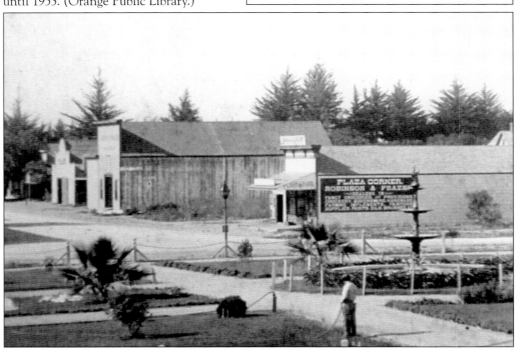

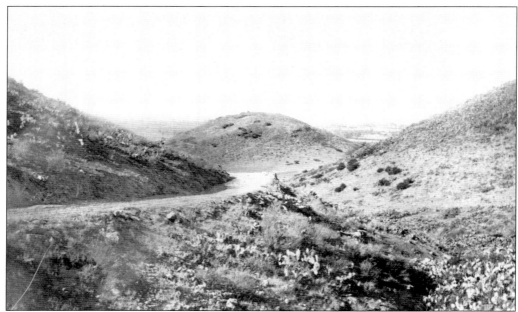

EL MODENA GRADE, C. 1910. East of the Santiago Creek, the land began a slow climb towards the foothills. At what is now Esplanade Street, a small rise puts you up on what old-timers simply called "the mesa." Below, closer to the creek, was "the gravel." Where Chapman Avenue begins its climb up into the foothills was Tom Thumb Hill, which is visible in the center of this photograph. It was bulldozed away in 1980. (Orange County Archives.)

VIEW FROM TOM THUMB HILL, C. 1890. Looking east and a little south from Tom Thumb Hill, the new town of El Modena is visible in the distance. Founded in 1886, the community was originally known as Modena, after a town in Italy. The "El" was added later when the post office complained the name too closely resembled Madera. (California State University, Fullerton, Special Collections.)

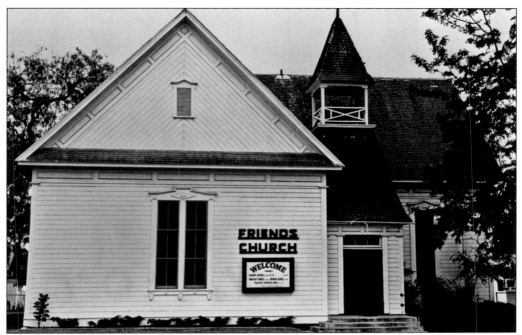

EL MODENA FRIENDS CHURCH, 1964. Many of the first settlers in El Modena were midwestern Quakers, and the El Modena Friends Church was a centerpiece of the community. The old sanctuary on Chapman Avenue, built in 1888, is now the banquet hall for Moreno's Mexican Restaurant. (First American Corporation.)

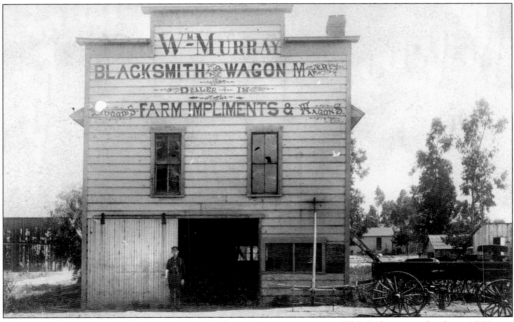

MURRAY BLACKSMITH SHOP, 1908. William Murray came to El Modena in the late 1880s to open a blacksmith shop. Twenty years later, he was still at his forge. Later owners kept the shop going into the 1930s. (Tom Pulley.)

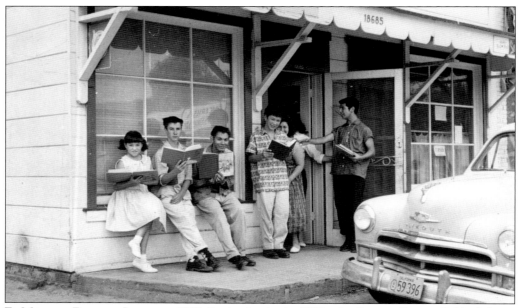

EL MODENA BRANCH LIBRARY, 1957. Beginning in the 1920s, the Orange County Public Library maintained branches in many smaller, outlying communities. The El Modena branch was in several different locations over the years, including this tiny (11-feet-by-25-feet) storefront on Chapman Avenue, near Earlham Street. (Orange County Archives.)

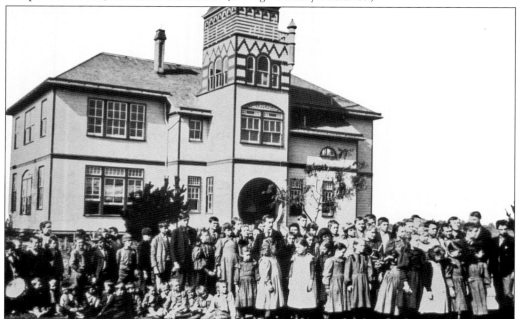

EL MODENA SCHOOL, 1889. For many smaller communities, the schoolhouse was the most important building in town. Substantial buildings like this one showed affluence, a concern for education, and (hopefully) helped to lure more families to the area. The El Modena Elementary School District eventually joined the new Orange Unified School District in 1953. (Orange Public Library.)

LINCOLN SCHOOL, C. 1960. Prior to 1947, El Modena was one of several school districts in Orange County that had segregated schools. Mexican American children had to attend school at the older Lincoln School building, located on the north side of Chapman Avenue, west of Hewes. (First American Corporation.)

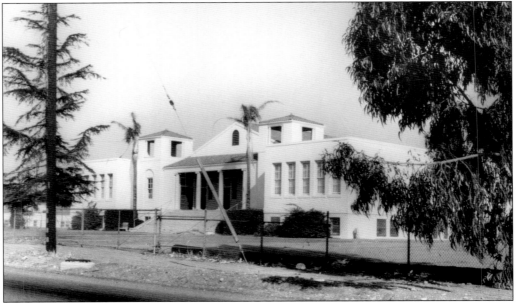

ROOSEVELT SCHOOL, C. 1960. Barely a hundred yards to the east, Anglo children attended the newer Roosevelt School. The El Modena Elementary School District was a defendant in the *Mendez v. Westminster* lawsuit that ended school segregation in California. All local students were then divided between the two schools, which were utilized into the 1960s. (First American Corporation.)

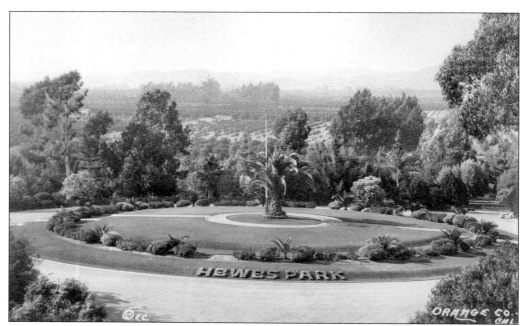

HEWES PARK, C. 1925. David Hewes owned one of the largest ranches in the Orange area, with nearly 800 acres spread between El Modena and Tustin. In 1905, he built a park on a little hill at the northwest corner of La Veta Avenue and Esplanade Street and opened it to the public. For more than 30 years, Hewes Park was a popular tourist destination. (Tom Pulley.)

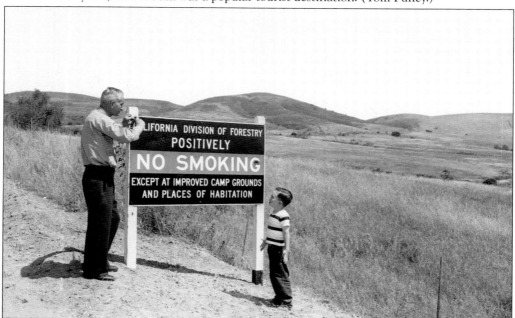

FIRE WARNING, PETERS CANYON, 1954. State Forest Ranger Joe Scherman posts a no smoking sign (with help from his son). Peters Canyon was part of the Irvine Ranch for many years. Beginning in the 1980s, much of the area was subdivided for housing. (Old Courthouse Museum, Geivet Collection.)

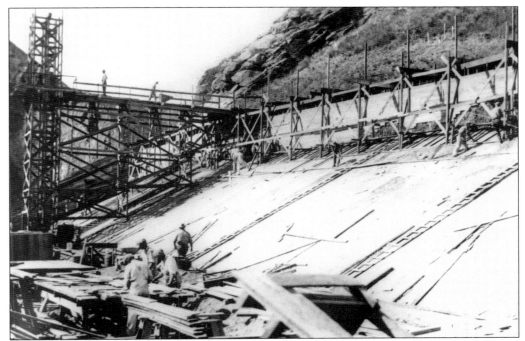

SANTIAGO DAM UNDER CONSTRUCTION, 1931. Built as a joint project of The Irvine Company, and the Serrano and John T. Carpenter irrigation districts, the Santiago Dam ended years of legal battles over the waters of Santiago Creek and created Irvine Lake. (Orange Public Library.)

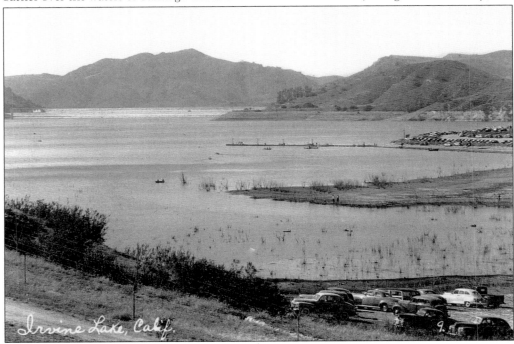

IRVINE LAKE, C. 1948. Built for irrigation and flood control, in 1941 Irvine Lake was also opened for fishing, and remains a popular recreational area. (First American Corporation.)

ORANGE PARK ACRES, 1928. Frank Mead Sr. and Mervin Monnette laid out Orange Park Acres as an agricultural community in 1928. The lone building visible is the sales office, at the corner of Chapman Avenue and Orange Park Acres Boulevard. Citrus growing, poultry raising, and horse ranching became the hallmark activities of Orange Park Acres. While some of the community

has been annexed to Orange, part of the old tract remains as unincorporated county territory, whose residents cherish its semirural atmosphere. (© Ronald D. Sands, Historical Panoramics of Orange County.)

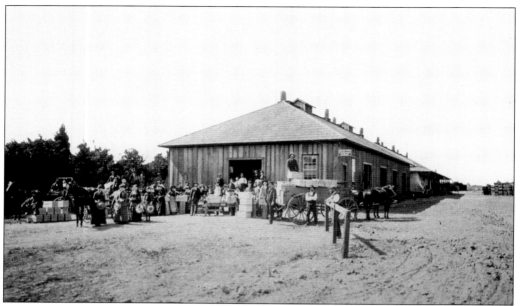

McPherson Brothers Packinghouse, c. 1885. Robert and Stephen McPherson settled east of Orange in 1872 and became the area's most prominent grape growers. In 1886, during the railroad boom, they subdivided part of their vineyards to lay out the town of McPherson. The tract was located on the north side of Chapman Avenue at McPherson Road. (University of California, Irvine, Don Meadows Collection.)

McPherson Brothers Raisin Label, c. 1885. Raisins were an important crop in the days before the railroad, because they could be shipped over long distances. But in 1886–1887, a blight struck the local vineyards, decimating the industry and bankrupting the McPhersons. Their little town soon faded away. (Author's collection.)

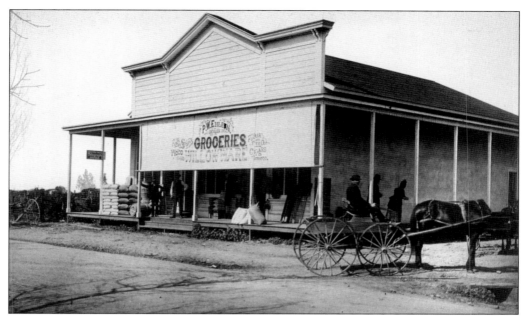

P. W. EHLEN'S FIRST STORE, MCPHERSON, 1887. P. W. Ehlen was not yet 25 when he opened his first general store in McPherson in 1887. Two years later, in partnership with Henry Grote, he launched the Ehlen and Grote Company, which grew to be Orange's largest retailer. Ehlen was a beloved figure around town until his death in 1950. (University of California, Irvine, Don Meadows Collection.)

ORANGE'S CHINATOWN, C. 1910. No photographs of Orange's little Chinatown seem to have survived, but Al Eisenbraun (1899–1988) made this sketch from memory in 1985. The store, laundry, and bunkhouse shown here were located on the west side of Glassell Street, just north of the Santiago Creek. Many of the men worked as laborers on the local ranches. The population was never large, and in 1924, the last of the old residents moved out. (Author's collection.)

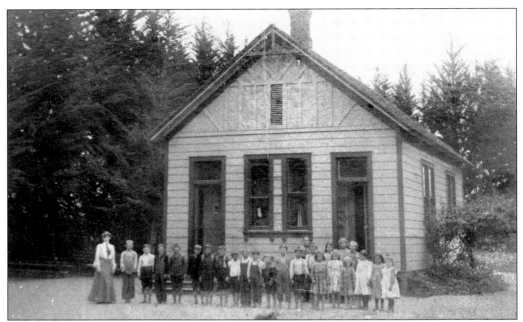

WEST ORANGE SCHOOL, C. 1900. West Orange School was established in 1890 to serve the scattered farm families on the west side of town. It was located near what is now La Veta Avenue and Flower Street, not far from the West Orange station on the Southern Pacific Railroad. The two doors were to provide separate entrances for boys and girls. (Pat Hearle.)

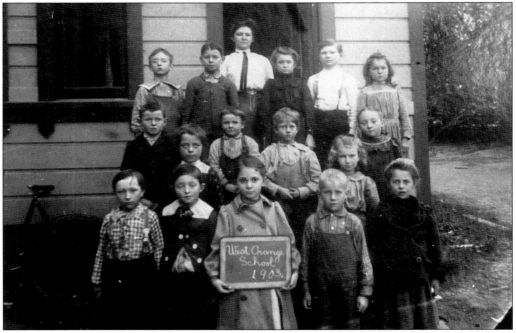

WEST ORANGE SCHOOL STUDENTS, 1903. Belle Jennings Benchley poses with her students in 1903. Only one teacher taught all eight grades at West Orange. Two years later, attendance had dropped so low that the school was closed. (Pat Hearle.)

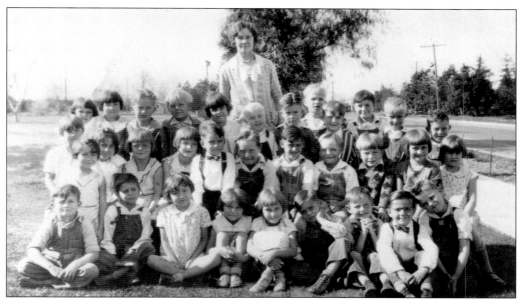

WEST ORANGE SCHOOL STUDENTS, 1930. In 1924, as residential development began to come to the west side of town, West Orange Elementary School was revived and a new six-classroom, brick building was constructed on the site of the present campus. Lotta Brandon, seen here with her first grade students, also served as principal of West Orange from 1924 to 1944. (Orange Public Library.)

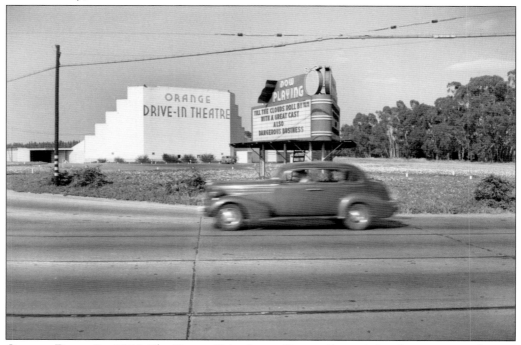

ORANGE DRIVE-IN, 1946. The Orange Drive-In was Orange County's first drive-in movie theatre. It opened in 1941 on the north side of Chapman Avenue at what is now State College Boulevard, and screened its last feature in 1994. (Old Courthouse Museum, Geivet Collection.)

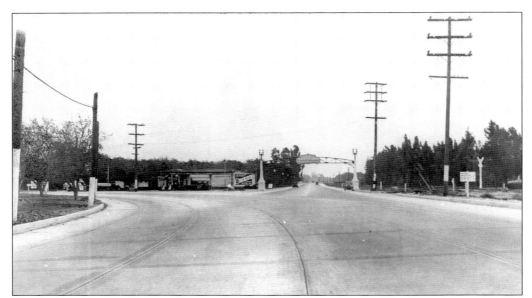

STATE HIGHWAY NEAR CHAPMAN AVENUE, 1932. The first state highway through Orange County followed surface streets, winding through the various towns. From Manchester Avenue, it turned east on Chapman Avenue, then south on Main Street. The City of Santa Ana later opened Santa Ana Boulevard to divert traffic from Orange. In this view, looking south, the turn to Chapman Avenue is on the left and the archway over Santa Ana Boulevard is straight ahead. (First American Corporation.)

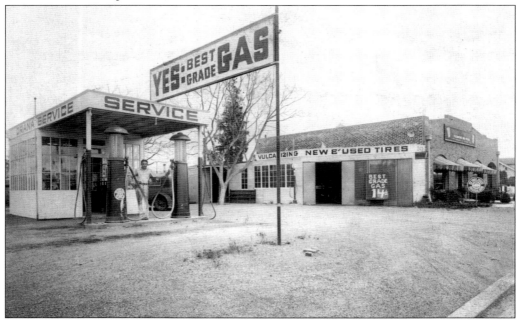

ORANA SERVICE STATION, C. 1930. At the turn in the state highway at Chapman Avenue and Main Street, a little business district grew up in the 1910s and 1920s. Because it was midway between Orange and Santa Ana, it was dubbed "Orana." The Orana Service Station operated in the late 1920s and early 1930s at 243 South Main Street. (Gladys Reeves.)

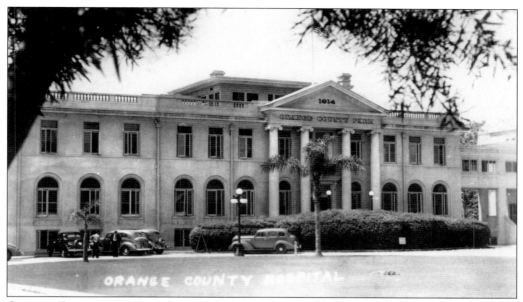

ORANGE COUNTY HOSPITAL, C. 1938. Across the state highway from the Chapman Avenue turn was the Orange County General Hospital, which opened in 1914. The county also cared for indigents here, in what was known as the county "poor farm." (Tom Pulley.)

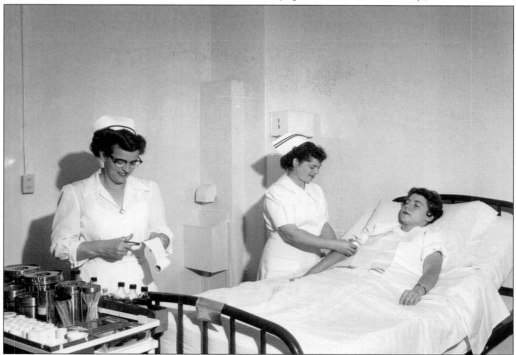

ORANGE COUNTY HOSPITAL NURSES, 1954. Nurses' training was another function of the County Hospital. The county operated the hospital for more than 60 years, finally selling it to the University of California, Irvine in 1975. The original 1914 building still stands, tucked away behind the modern UCI Medical Center. (Old Courthouse Museum, Geivet Collection.)

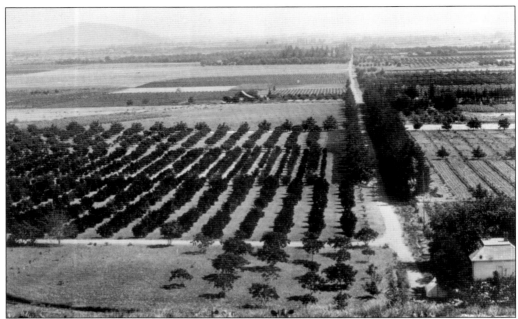

LOOKING ACROSS VILLA PARK, C. 1894. Center Street stretches into the distance through the orchards and windbreaks of Villa Park, or Mountain View, as the community was known in the early years. While Villa Park has always had close ties to Orange, in 1962 the community voted to incorporate as a separate city. (University of California, Irvine, Don Meadows Collection.)

SANTIAGO CANYON ROAD, C. 1960. Before Chapman Avenue was extended over the El Modena Grade, this lower stretch of Santiago Canyon Road was the usual way up to Irvine Park and the Santa Ana Mountains beyond. Looking east through the orange groves at Santiago Boulevard, Don Sexton's old grocery store and service station on the corner has already clearly been abandoned. (Orange County Archives.)

Six

MEMORABLE EVENTS

Looking back on the history of Orange, there are many events that stand out. Some were happy times, like the first street fair in 1910, and some were tragic times, like the flood of 1938. Occasionally national events touched Orange, like wars and depressions. Other events were purely local, like the big freeze of 1913. Community events and holidays followed the seasons. They were a chance for the community to come together. All of them help paint a picture of early Orange.

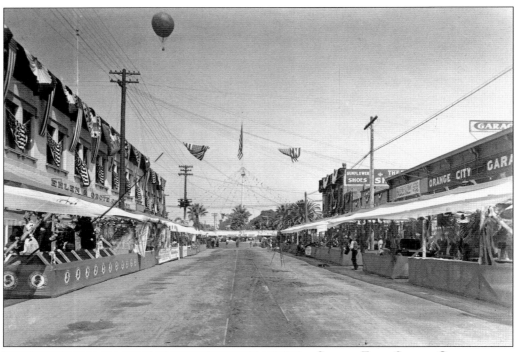

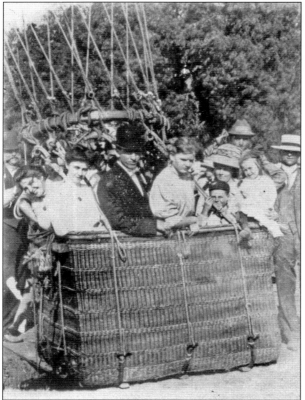

STREET FAIR, SOUTH GLASSELL STREET, 1910. In the early 1900s, the various communities around Orange County took turns sponsoring an annual celebration. In 1910, Orange hosted a street fair with exhibits, carnival attractions, music, sports, and food. Notice the tethered balloon in the sky. (Author's collection.)

STREET FAIR BALLOON ASCENSION, 1910. Some old-timers said there were two prices for this attraction, one for the balloon ascension and souvenir photograph, the other just to stand in the basket and have your picture taken while remaining safely on the ground. (Orange Public Library.)

STREET FAIR CROWDS, 1910. Booths ring the Plaza at the 1910 Street Fair. A note on the back of an original postcard explains, "We certainly are proud of Orange. We had a fine fair. This is the way it looked all around the Plaza and up and down all the streets for a block. 4 & 5 thousand people in one day." (Orange County Archives.)

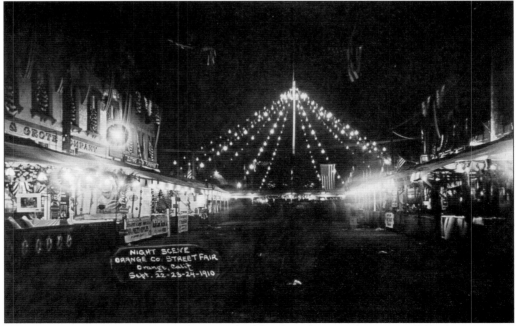

STREET FAIR AT NIGHT, 1910. Photographs like this, showing downtown full of excitement, inspired today's Orange International Street Fair, first held in 1973. (Orange Public Library.)

WORLD WAR I BOND RALLY, 1917. The crowds turned out for a Victory Bond rally in the Plaza in 1917. Bonds were sold during both world wars to help finance the conflicts. Individuals, businesses, and organizations all bought bonds; everyone was expected to do their part. (Orange Public Library.)

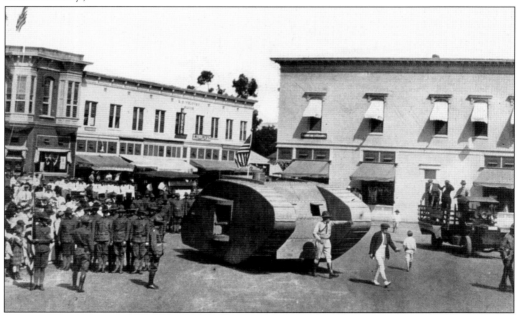

WORLD WAR I PARADE, 1918. A bond drive parade rolls through the streets of Orange in 1918. The tank was presumably a model, to protect the pavement on the city streets. Scores of local men served in the military during World War I, but many of them never went overseas. (Orange Public Library.)

WORLD WAR I, HANGING THE KAISER IN EFFIGY. Wartime fervor was running high in Orange during World War I when Germany's Kaiser Wilhelm was hung in effigy in the Plaza during a bond rally. (Orange High School collection.)

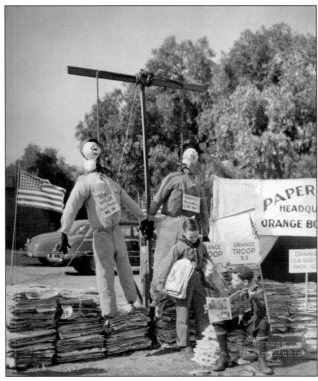

WORLD WAR II, HANGING HITLER AND HIROHITO IN EFFIGY. New enemies were under attack during World War II when effigies of Adolf Hitler and Japan's Emperor Hirohito were hung at a Boy Scout paper drive in 1945. (Author's collection.)

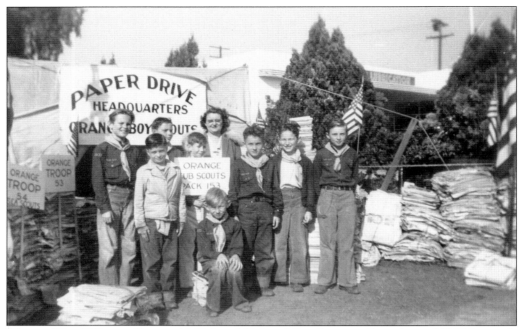

WORLD WAR II PAPER DRIVE, 1945. Local Cub and Boy Scouts collected over 160,000 pounds of paper during their big scrap drive in the spring of 1945. Their headquarters was located just east of the Elks Lodge on Chapman Avenue. (Author's collection.)

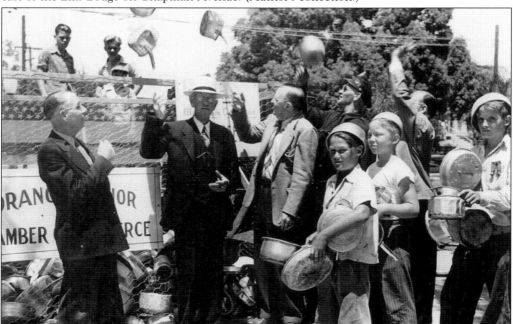

WORLD WAR II ALUMINUM DRIVE, C. 1943. City officials and local youngsters pitch in on an aluminum drive, sponsored by the Junior Chamber of Commerce. All sorts of items were collected on the home front, from old rags to silk stockings. Even used cooking fats were valuable for the war effort. (Orange Public Library.)

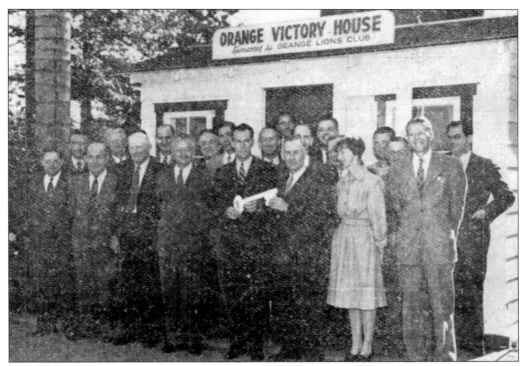

WORLD WAR II, VICTORY HOUSE IN PLAZA, 1943. Built by the Lions Club as a headquarters for local bond drives, the Victory House was staffed by volunteers from local churches and civic organizations. At its dedication, shown here, Lions Club president Ray Terry presented the key to Mayor Floyd W. Parsons. Second from the right is Roy Edwards, the chairman of construction committee. (Author's collection.)

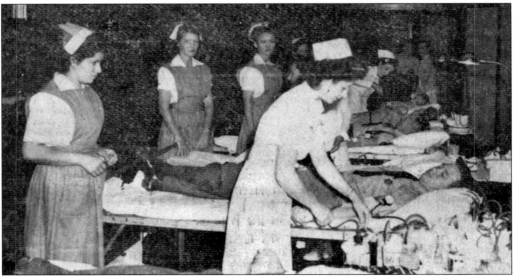

WORLD WAR II BLOOD DRIVE, 1943. Along with its relief work around the world, the Red Cross sponsored local blood drives during the war, like this one held in December 1943. According to the article in the *Orange Daily News*, the drive collected 249 pints of blood. (Author's collection.)

WORLD WAR II, CAMP RATHKE. In 1942, the U.S. Army commandeered Irvine Park as a military training base. In 1943 they moved just outside the park to the old county health camp. The camp was named Camp Rathke, in honor of Lt. George Rathke of Orange, who had died during a training exercise earlier that year. The buildings were later used for a Boy Scout camp. (Jim Sleeper.)

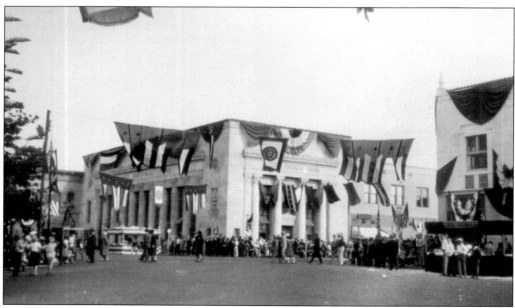

ARMISTICE DAY PARADE, 1928. Armistice Day was Orange County's biggest annual celebration in the 1920s, marking the end of World War I. The local communities took turns hosting parades and other events. Orange did the honors in 1928, when 50,000 people attended a "Pageant of All Nations," which, according to the *Los Angeles Times*, was "the story of peace among the nations of the world . . . told in costume, song and story." Armistice Day was renamed Veterans Day in 1954. (Orange Public Library.)

SHANTIES ALONG THE SANTIAGO CREEK, 1934. During the Depression years, a number of people were reduced to living in shacks along the Santiago Creek, between Orange and Santa Ana. The residents dubbed it "Orange Dump." An *Orange Daily News* reporter visited the area in 1931: "We found men of all colors and beliefs living together, enjoying life—such as it is—as much as we enjoy our luxuries. . . . [W]e found men who at one time had good jobs, and good families. . . . It costs little for these men to live—$1.40 a week if you don't get extravagant, one man told us—yet apparently none of them are suffering from over-eating. But they are contented, and loyal to one another." (Both, Jim Sleeper.)

ORANGE CITY PARK, C. 1940. During the Depression, federal funds became available for all sorts of local projects. In 1933, the city began development of a new city park along Santiago Creek, with help from both the SERA (State Emergency Relief Administration) and the WPA (Works Progress Administration). Dedicated in 1937, the park was renamed W. O. Hart Park in 1964, in honor of the longtime editor of the *Orange Daily News*. (Tom Pulley.)

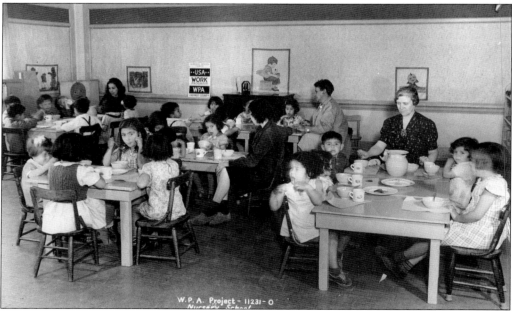

WPA NURSERY SCHOOL, CYPRESS BARRIO, 1939. The WPA sponsored all sorts of local projects. Some were designed to provide jobs, others to provide community services. One of the projects was a nursery school and lunch program for Mexican American children from the Cypress barrio. Classes were held in the Cypress Street School. (Orange County Archives.)

FROZEN FOUNTAIN, 1913. The big freeze of January 1913 was devastating to local citrus ranchers. Temperatures reached as low as 18 degrees, destroying fruit and even causing some trees to burst open. The Plaza Fountain was turned into an ice sculpture. (Author's collection.)

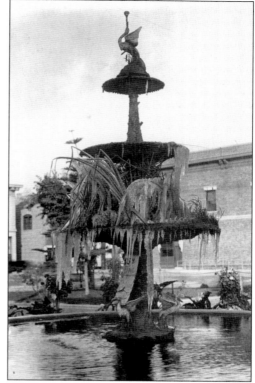

SANTA ANA RIVER, 1916 FLOOD. Two floods, 10 days apart, in January 1916 washed out almost all the bridges in Orange County. Here is what was left of the Santa Fe Railroad bridge over the Santa Ana River near Olive with a couple of daring souls walking across. (Walter E. Crane.)

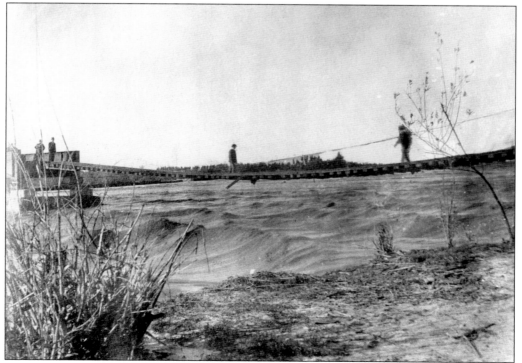

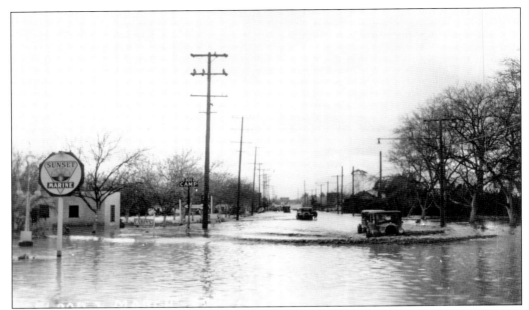

WEST CHAPMAN AVENUE, 1938 FLOOD. The floods of 1938 swept through Orange County, killing scores of people, destroying dozens of homes, and burying hundreds of farms in silt. Here floodwaters cover Chapman Avenue near Flower Street, looking west, with the old county hospital just visible in the distance. (Tom Pulley.)

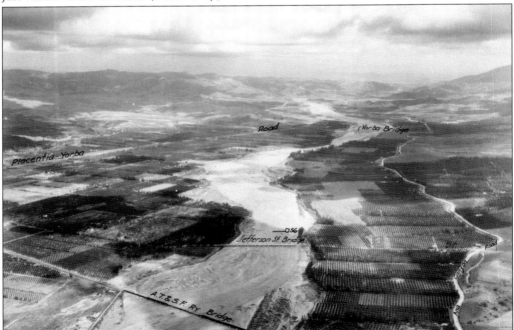

SANTA ANA CANYON, 1938 FLOOD. Heavy rain and melting snow turned the Santa Ana River into a torrent that roared through the Santa Ana Canyon. The river broke its banks and surged through Atwood, La Jolla, downtown Anaheim, and all the way to Buena Park. (Orange County Archives.)

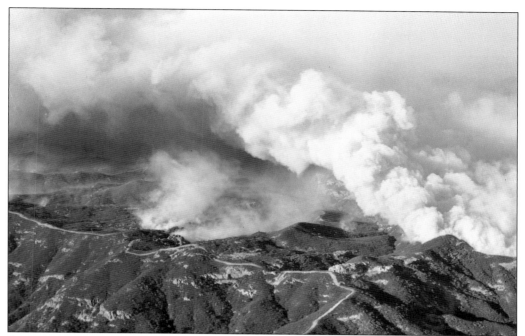

GREEN RIVER FIRE FROM THE AIR, 1948. The weeklong Green River Fire was one of the largest in Orange County's history, blackening some 47,000 acres between Corona and Orange. It is shown here burning in the Black Star Canyon area. (Old Courthouse Museum, Geivet Collection.)

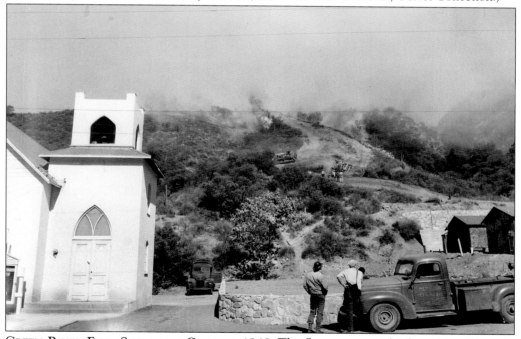

GREEN RIVER FIRE, SILVERADO CANYON, 1948. The flames came right down into Silverado Canyon, but firefighters managed to save almost every home. The old Silverado Community Church is on the left. (Old Courthouse Museum, Geivet Collection.)

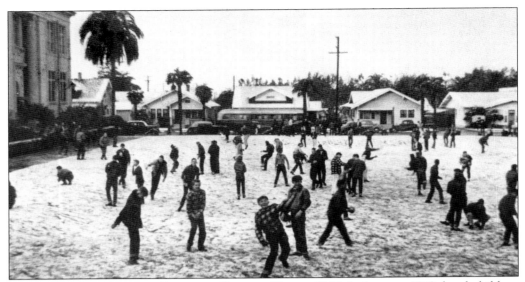

SNOWBALL FIGHT ON THE LAWN AT ORANGE HIGH, 1949. In January 1949, local children awoke to a remarkable sight—snow in Orange! Students at Orange Union High School quickly discovered that snowball fights were more fun than studying and the school finally gave up, canceling classes for the rest of the day. (Orange High School.)

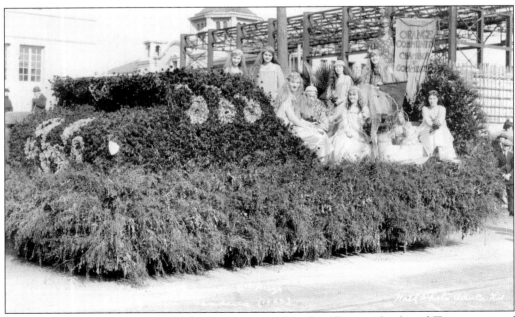

ORANGE'S ROSE PARADE FLOAT, 1923. Orange had its first float in the famed Tournament of Roses parade in 1923. The Orange Community Chamber of Commerce arranged for the float, which featured a bevy of local beauties and clusters of carnations. Orange next had a float in the 1940 parade and provided the Rose Queen, Norma Christopher, for the 1947 celebration. (Tom Pulley.)

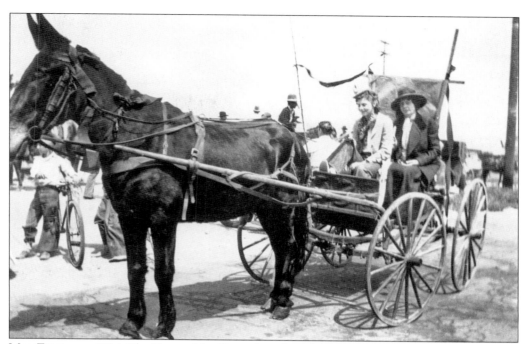

MAY FESTIVAL, 1934. The Orange May Festival was launched in 1933 as a break from the troubled times of the Great Depression. For the first few years, the celebration featured an old-time theme, with period costumes and vehicles. (Author's collection.)

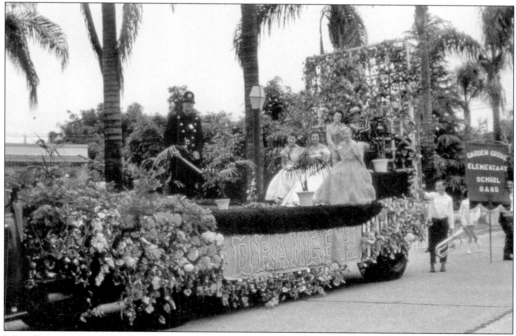

MAY FESTIVAL, 1950. While the May Festival evolved over the years, a parade was always the main event. Orange Union High School entered this float in 1950. The festival continued as an annual event on into the 1990s. (Orange Public Library.)

CROWNING THE QUEEN, MEXICO LINDO, 1948. In the late 1940s, members of the Holy Family Catholic Church sponsored an annual "Mexico Lindo" celebration in the Cypress barrio, with a parade, a street dance, carnival booths, and plenty of food. Some 4,000 people attended in 1948, when Fr. Michael Twomey crowned Catalina Morales as Queen. Her attendants are Carmen San Roman and Maria Louisa Raya. (Orange Public Library.)

TICKET BOOTH, MEXICO LINDO, 1948. The Mexico Lindo celebrations were also fund-raisers for various organizations. Here Rafaelita Nava Garcia and Enedina DeLeon sell tickets to raise money for the USO. Traditional Mexican clothing was also part of these celebrations. (Orange Public Library.)

CHRISTMAS AT THE HOTEL ROCHESTER, 1922. Immanuel Lutheran Church met in the old Hotel Rochester in 1922–1923 and celebrated their first Christmas there. (Harold Dittmer.)

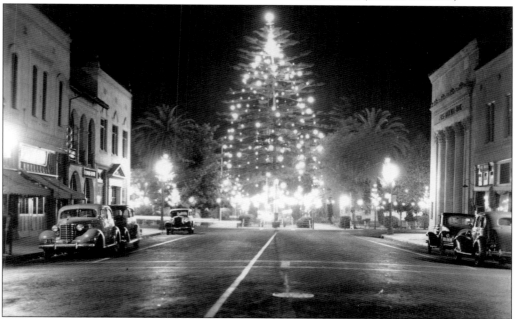

CHRISTMAS ON THE PLAZA, 1937. This classic view was taken by local photographer Ronald Boring at 11:00 p.m. with a time exposure (to avoid the traffic, no doubt). The Star Pine on the east side of the Plaza park has served as Orange's community Christmas tree since the 1910s. (Author's collection.)

ACROSS AMERICA, PEOPLE ARE DISCOVERING SOMETHING WONDERFUL. *THEIR HERITAGE.*

Arcadia Publishing is the leading local history publisher in the United States. With more than 4,000 titles in print and hundreds of new titles released every year, Arcadia has extensive specialized experience chronicling the history of communities and celebrating America's hidden stories, bringing to life the people, places, and events from the past. To discover the history of other communities across the nation, please visit:

www.arcadiapublishing.com

Customized search tools allow you to find regional history books about the town where you grew up, the cities where your friends and family live, the town where your parents met, or even that retirement spot you've been dreaming about.